DEWSBURY
THROUGH TIME
John Ketton &
Stuart Hartley

AMBERLEY PUBLISHING

Acknowledgements

The vast majority of the old images are from Stuart Hartley's own collection of old postcards, together with a few of John Ketton's photographs taken in the 1970s and 1980s. For the rest, we have to thank Margaret Watson of the *Dewsbury Reporter*, Donald Pierson and Tony Cree for letting us use images from their collections. We also have to thank John S. Whiteley for giving us permission to include his picture of a steam train passing Ravensthorpe station. All the recent images were taken by John Ketton, with the exception of several taken by his brother, Paul Ketton. We are also very grateful to Paul for piecing all our work together.

We dedicate this book to the memory of John & Paul's father, Eric Ketton, who sadly passed away during the compilation of this book.

First published 2013

Amberley Publishing
The Hill, Stroud, Gloucestershire, GL5 4EP
www.amberley-books.com

Copyright © John Ketton & Stuart Hartley, 2013

The right of John Ketton & Stuart Hartley to be identified as the Authors of this work has been asserted in accordance with the Copyrights, Designs and Patents Act 1988.

ISBN 978 1 4456 1822 7 (print)
ISBN 978 1 4456 1830 2 (ebook)

British Library Cataloguing in Publication Data.
A catalogue record for this book is available from the British Library.

Typesetting by Amberley Publishing.
Printed in Great Britain.

Introduction

The history of Dewsbury can be traced back to at least Saxon times, when it was a centre of considerable importance. The earliest date of any significance was AD 627 when Paulinus, the first Bishop of York, preached on the banks of the River Calder. The very first church was built in wood in the eighth century, but was soon replaced with one built of stone. The church was enlarged in the twelfth and thirteenth centuries, and it became the mother church for an area covering 400 square miles, stretching from east of Wakefield to east of Burnley. The Minster was again enlarged in the 1760s when the tower was added, and finally, in the 1880s, to create a church of cathedral proportions. Unfortunately, Dewsbury missed out to Wakefield in 1888 when the seat of the bishop for the new diocese was decided. Patrick Brontè was curate at Dewsbury from 1809 to 1811. John Wesley visited the area five times in the mid-eighteenth century, and the Methodist Society was established in 1746.

Dewsbury was listed in the Domesday Book in 1086. It was known then as Deusberia or Deusberie, which was thought to mean 'fortified place by a stream'. The population was very small then, consisting of just nine households, two smallholders and one priest, whereas Earlsheaton, which is now part of Dewsbury, had nine villagers, twenty-two smallholders, eleven freemen and three priests.

Dewsbury is also well known for its market. It was established in the fourteenth century for local clothiers. Outbreaks of the plague in 1593 and 1603 closed it down, until it reopened in 1741. It moved to its present site in the early twentieth century and is now the biggest open market in Yorkshire.

The main industries of Dewsbury were based on mining and textiles, and all the associated trades involved. The Ingham family were well known for many of the mines in the area, particularly in Thornhill. However, the real prosperity was based on the woollen trade, notably blankets, followed by shoddy and mungo, an early nineteenth-century recycling process. The town imported old heavy cloth, such as used military uniforms, and quickly became the commercial centre for the 'Heavy Woollen District'. Large mills sprang up all around the town; these were extended and rebuilt into massive premises, notable ones being Machell's Mill in the centre of Dewsbury and Spinkwell Mills on Halifax Road, belonging to Mark Oldroyd.

Dewsbury was given a boost to communications in the eighteenth century, when the Aire & Calder Navigation allowed canal access initially to Wakefield and then to other parts of the

country, facilitating the movement of all goods produced in the town. By the mid-nineteenth century, the railways reached Dewsbury, allowing the mass movement of rags for the shoddy mills. At one time, the town centre had three railway stations and at least another five within the borough. This led to the construction of many railway companies, goods storage sheds and yards around the town centre.

Wormald & Walker Ltd of Britannia Mills made their mark in Dewsbury through the production of woollen blankets, 'Dormy', which were exported throughout the world. The firm became very wealthy, and by 1818, Hague & Cooke & Co., who were responsible for starting the firm, had formed their own bank, which was taken over by the West Riding Union Bank in 1855. The bank formed part of the Lancashire & Yorkshire Bank, later Martins Bank and now Barclays.

In 1857, the Dewsbury Pioneers' Industrial Society was born, and in 1880 the society built its own impressive Pioneers Building in Northgate. This served the society well for over 100 years. Since then, different ownership has caused untold damage to the building. Fortunately, Kirklees Council are spending money to refurbish this important building; it is a long project, but worthwhile in the long run.

As Dewsbury expanded, it needed public buildings to hold council meetings, worthy to reflect the status of the town. A splendid town hall was designed and opened in 1889 in the centre of Dewsbury. The building still stands proud today overlooking the town centre.

About the Authors

John is a committee member of Dewsbury Matters, the local history group, and is also the president of the photographic society local to Dewsbury. He has been a member for thirty-four years and in this time has achieved a Credit award from the Photographic Alliance of Great Britain. Stuart is a retired lecturer in Architecture at Huddersfield University. He is currently the chairman of Dewsbury Matters, and has produced and written many articles over the last ten years for their annual booklet. He gives many talks on local history to groups in the area, of which he is very well known and respected.

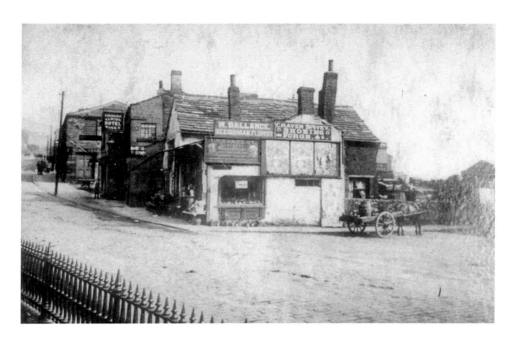

Town Hall Site, *c.* 1885

The cluttered group of buildings that was to become the site of the new town hall included Ballance's fruit, vegetables and seed merchant, Craven Spivey, blacksmith, and the Albion Hotel. The site was cleared, and Alderman J. P. Fox laid the foundation stone on 12 October 1886 and work began. Only three years later, on 17 September 1889, the town hall was officially opened. The total expenditure was in excess of £40,000. Local benefactors provided the extra money to complete the project, including Mark Oldroyd, who paid £1,000 for the clock and bell chimes.

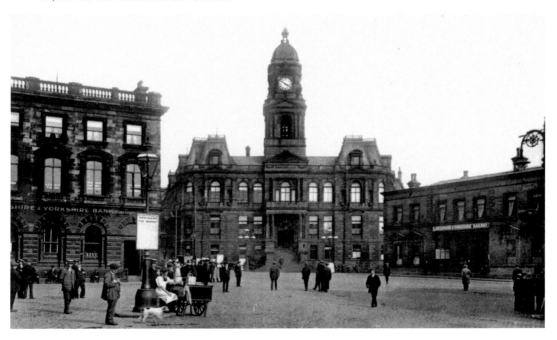

Town Hall, *c. 1910*

The impressive building was modelled on Leeds Town Hall and stood on the higher ground, overlooking the market place. The style is Italianate, three storeys high and five bays wide, with Corinthian orders supporting a cupola. The plans were drawn up by local Dewsbury architects, Holtom & Fox. The building on the right was the entrance to the Lancashire & Yorkshire railway station, built some years before the town hall, in 1867, and closed in 1930. The road to the left was the start of the two roads that led to Leeds and Wakefield.

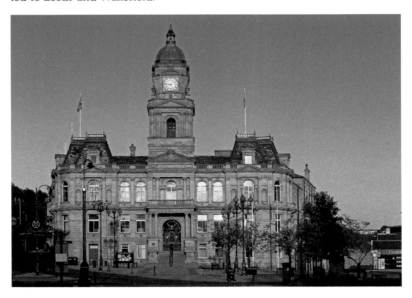

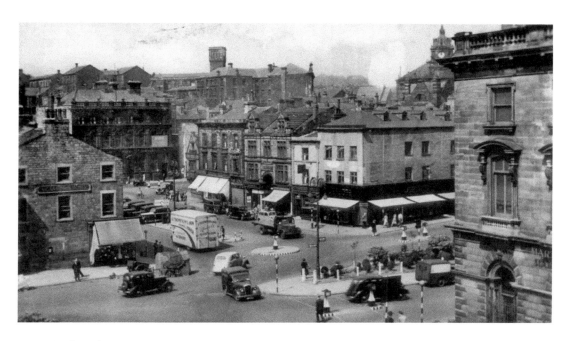

Market Place, *c. 1950*

These views of the market place are quite dramatic, and have hardly changed over the years. The exceptions are the shopfronts and the new shopping centre to the front left. Interesting features are the two banks, the former Midland in the centre, now HSBC, and what was previously Martins, now Barclays, to the right. When listed buildings legislation was being suggested in the 1960s, Martins removed the ornate balustrade to the roof, while the Midland retained theirs, and it is apparent which looks better. High on the skyline is the water tower, part of the massive railway warehouses in Wellington Road.

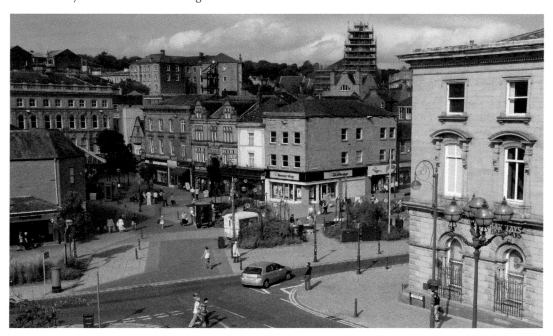

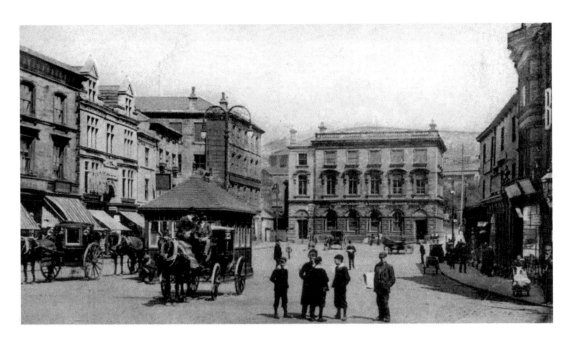

Market Place, *c.* 1900

A view from around the turn of the century, with the imposing Lancashire & Yorkshire Bank in the far centre. Formerly, the West Riding Union Banking Company had its headquarters in Huddersfield, which later became Martins Bank and is now Barclays. Shops are still in evidence around the arcade, mainly food shops. People would buy fresh food every day, as there were no refrigerators back then. Horse-drawn carriages can be seen awaiting their fares next to the small pitched-roof building, which was known as the 'cabman's shelter', being the waiting area for hackney carriage proprietors. Today, it is a pedestrian area with seating and planted areas.

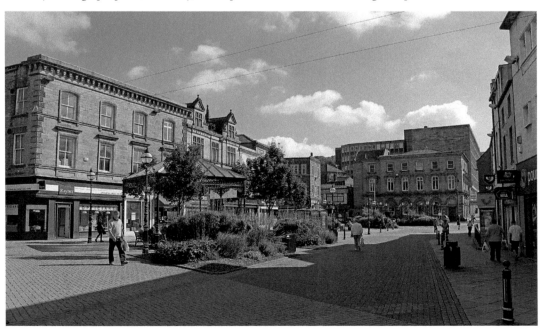

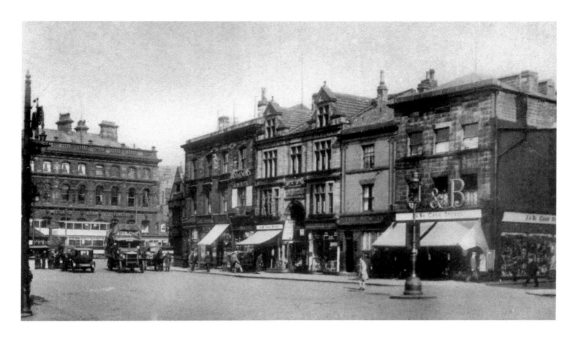

Market Place, c. 1910

Originally the site of the open market, the market place still remains a very busy shopping area in the town centre. We now see trams and commercial vehicles within the town. Many of the key shops were situated here, including J&B's, who, over the years, commended seven different sites within the town. J&B's were one of the first department stores and sold everything from ladies' clothes to toys. To the right of the arcade is Balance & Son, the shop that had to be relocated due to the requisitioning of their previous site for the new town hall.

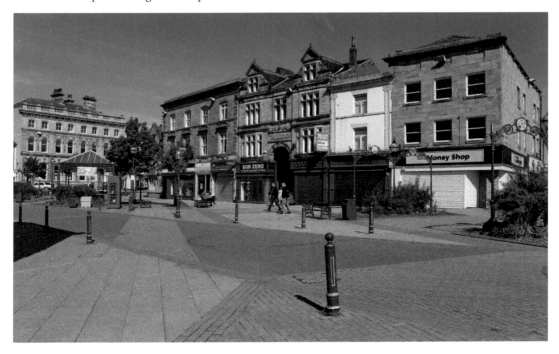

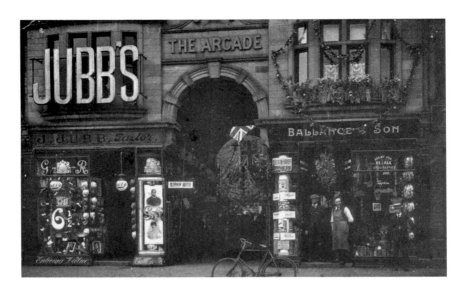

The Arcade, *c.* 1910

Construction commenced in 1897 to celebrate Queen Victoria's Diamond Jubilee, and was completed in 1899. J. Jubb's Tailors is advertising straw hats, although if it is the same company, it is better known for grocery and provisions. Balance & Son can be seen, decorated with flowers and advertising their produce. Looking carefully, there are decorations in the arcade, possibly celebrating a Coronation. There are GR crests and pictures in Jubb's windows, which could suggest the Coronation of George V in 1911. Note the electric lights to the exterior of Jubb's shop. Today, only the shop fascias have changed.

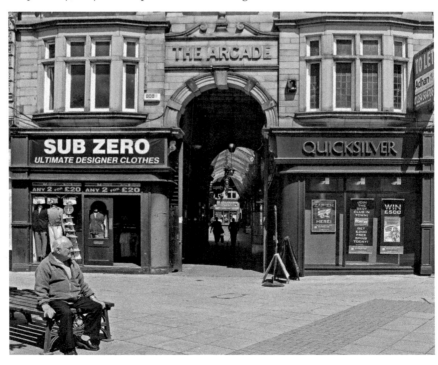

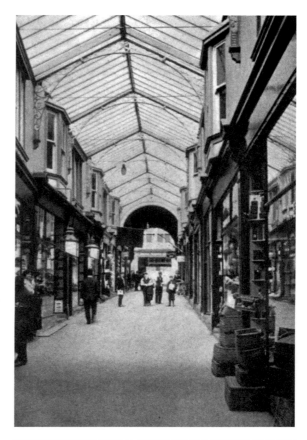

The Arcade, *c.* 1910

The interior of the arcade was carved straight through the existing buildings to form extra shops. This was roofed over with cast-iron glazing bars and glass, to give a weatherproof link from the market place to New Bridge Street, later to be renamed Corporation Street. When it was constructed, none of the shops had their own toilets; there was only one for all the proprietors, situated half way up the arcade. The arcade was carefully refurbished some twenty-five years ago and a corporate image of all the shop signs was employed, although the pawnbrokers had already opted out.

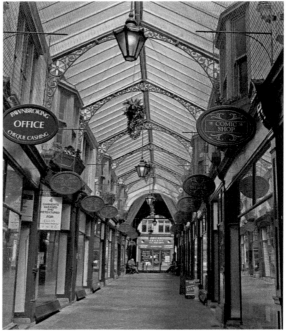

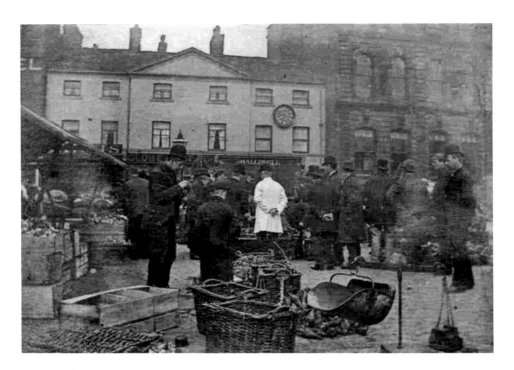

Market Place, *c.* 1880

A busy view of the open market, where scales and produce can be seen on the ground. This is the earliest picture in the book, believed to date from in the 1880s. Halliwell's was a maker of fine watches, and proudly displays Dewsbury's only community timepiece, predating the town hall and the Pioneers clocks. The white building with the pediment is a very early timber-framed building, believed to be the oldest shop in Dewsbury. The left-hand side of the building was removed and became the entrance to the Picture House, one of Dewsbury's early cinemas.

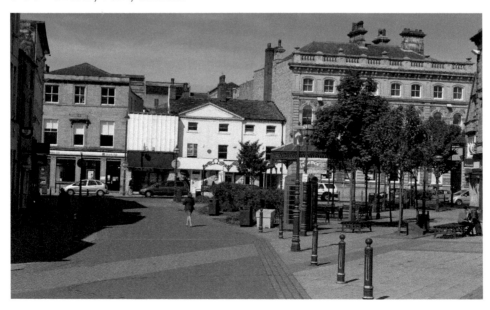

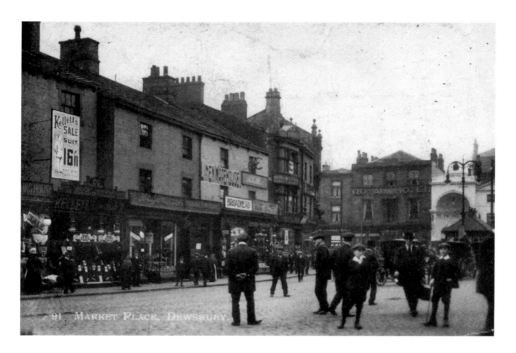

Market Place, *c.* 1910

Broadhead's stocked all haberdashery supplies and existed until the 1960s. To the left of this were the original premises of the oddly named Yorkshire Penny Bank Ltd, now the Yorkshire Bank. Salinksky's tailors also traded from this row. The Royal Hotel was Dewsbury's premier hotel, hosting visiting dignitaries. It previously stood on the present site of Barclays Bank. This site across the market place was redeveloped in 1851 and saw the Crown & Cushion public house disappear, and the Royal Commercial & Family Hotel was created. It was later Barclays Bank and is now Lloyds Bank.

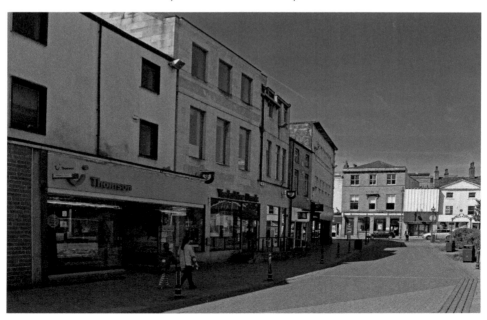

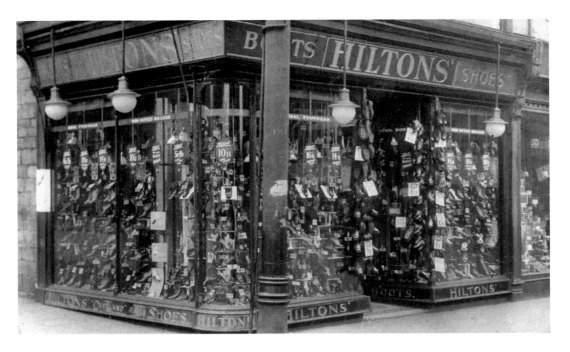

Hiltons', *c.* 1910

Hiltons' Boots and Shoes stood on the corner of the market place. The shoes were all in excess of 10s in old currency; this photograph is around 100 years old, making shoes a very expensive commodity! The corner became newsworthy on 12 October 1915, when a local tram ran away down Wakefield Road, careered across the front of the town hall, and embedded itself in Hiltons' shoe shop. The local photographers F. Hartley and Mark Cross, Borough Studios, would rush to the scene and, having taken the pictures, would have had them on sale that same day.

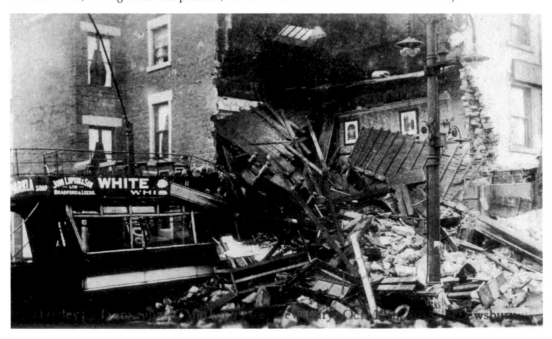

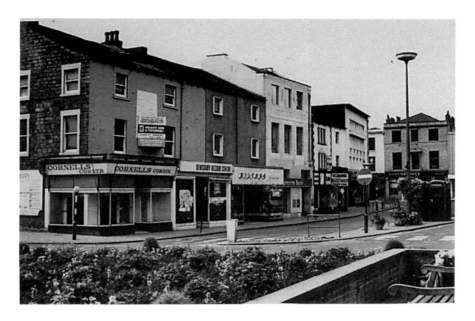

Market Place, 1979

By now, the same corner was known as Cornell's Corner, Hiltons' having moved down three spaces. To the left, part of a board can be seen; this was Dewsbury's road safety initiative, which indicated how many people had been killed and injured on the roads during the year and broke the figures down into months. The Scarborough Hotel, a Ramsden's Brewery property, was still there. The light-coloured ashlar stone building in the centre was the improved and extended premises of the renamed Yorkshire Bank. Finally, there is a new shopping development, ironically still retaining a shoe shop on the corner, Saxone.

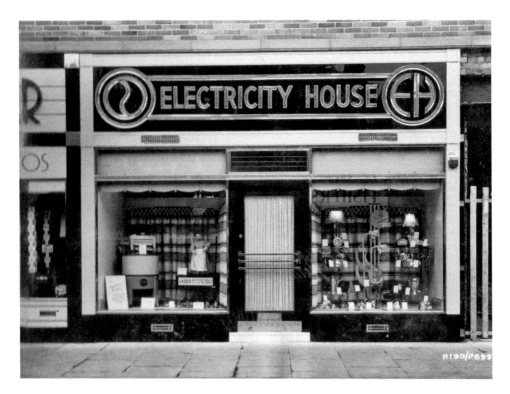

Crackenedge Lane, 1938

We have now moved onto Broadway House, built in 1937. It is most unusual in Dewsbury to have a building constructed in brick rather than traditional stone. The site was previously a series of industrial buildings straddling a beck, using it for water power, hence the name Foundry Street. The new site housed over twenty businesses, with two floors of offices above. One of the larger shops was Electricity House, later called YEB Showrooms. This occupied a unit that ran the full width of the building. The site is currently a Subway takeaway.

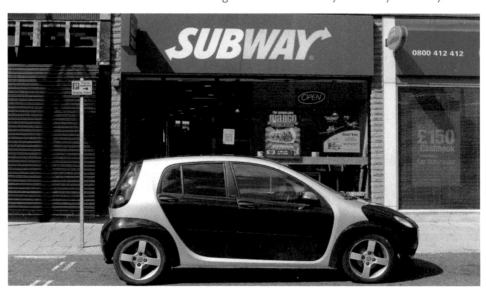

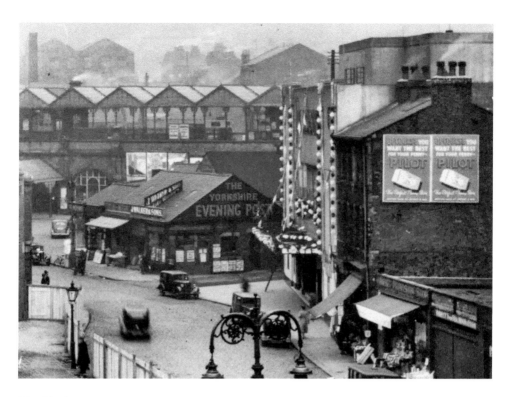

The Playhouse, 1937

Further along Crackenedge Lane stood the Playhouse Cinema, opened on 26 October 1931 and built for the independent Lou Morris chain. It was built as a theatre and cinema, with a 50-foot-wide stage and six dressing rooms. The first film shown was Charlie Chaplin's *City Lights*. It was taken over by the Associated British Cinemas (ABC) chain on 6 May 1935 and renamed ABC in 1963. One-day pop concerts continued to be staged until it was closed as a cinema on 11 December 1970. After being used as a bingo hall, Wilkinson's purchased the site for a new store.

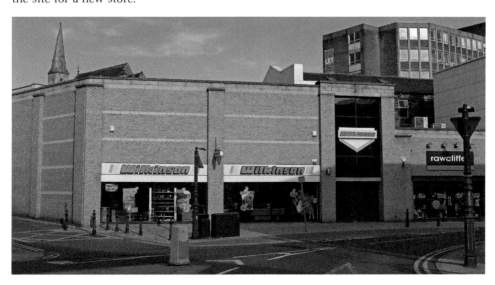

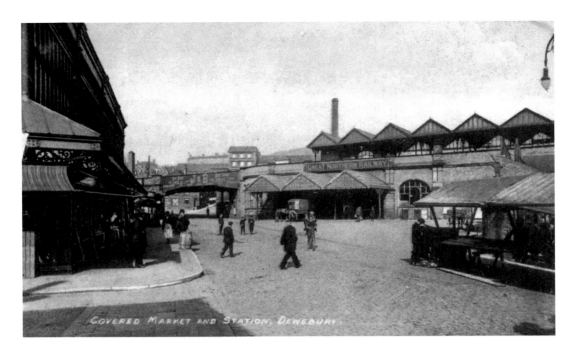

COVERED MARKET AND STATION, DEWSBURY.

GN Station, *c.* 1910 and 1979

The Great Northern's permanent station was opened in 1878; a temporary one had been constructed in 1874. Built on the site of Kiln Mills, it was the last station built to serve the town centre. Situated opposite the market, the station served the town very well, bringing in goods for industry, as well as the morning papers from London. Fish, including mackerel and herrings from the fishing ports of western Scotland, was sold from the station yard every morning. Local fishmonger Herman Pickles collected fresh herrings from his own personalised railway trucks for smoking at his adjacent premises.

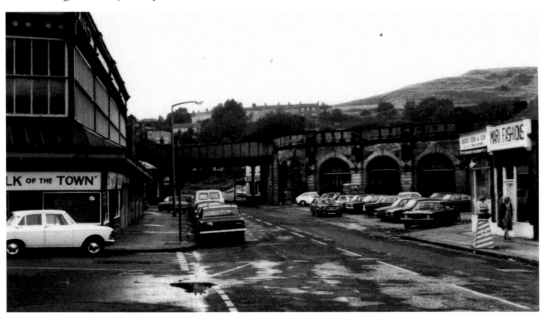

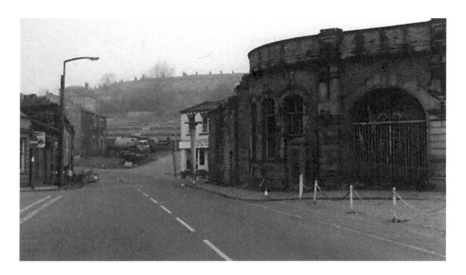

GN Station, *c.* 1980

The station had a facelift when the Queen arrived there in 1954 during her visit to Dewsbury. The station suffered badly as a result of a reduction of parcel traffic, which was now using road transport. It lasted ninety years, closing on 5 September 1964. Much of the station bed remained until the early 1980s, when it became part of the newly planned route for the ring road. The old cast-iron bridge was replaced with a wider, modern steel girder bridge, ironically to take the increasing traffic on the roads that would once have travelled by rail. The market still survives and the station forecourt is now a car park.

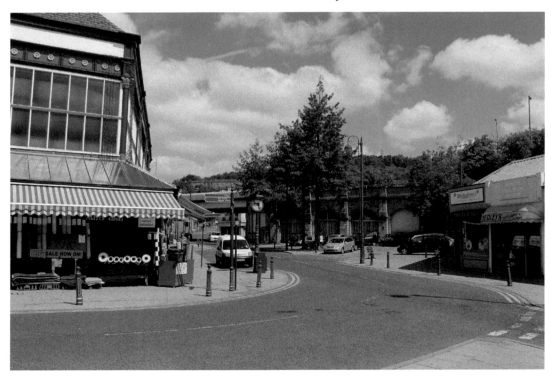

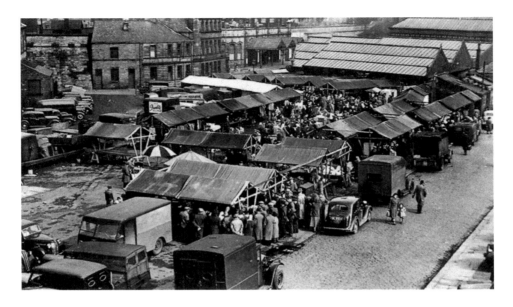

The Market, Cloth Hall Street, *c.* 1950

Dewsbury market has a great tradition. Established in the fourteenth century, outbreaks of the plague closed it down until it reopened in 1741 in the market place and along Crackenedge Lane. It moved to its present site in the early twentieth century and is now the largest open market in Yorkshire. From this view, it can be seen how near it was to the station for delivering produce. Crowds can be seen around Lou's stall; he was real market trader who almost reverse auctioned his goods. Customers would spend hours around his stall.

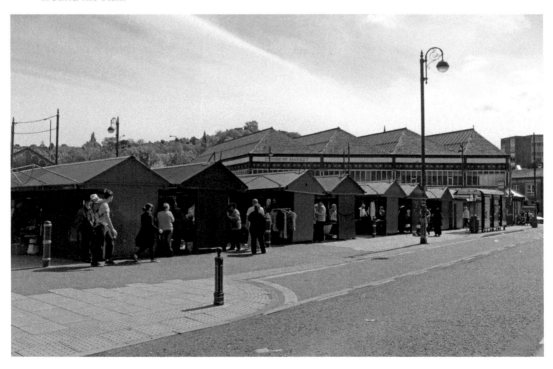

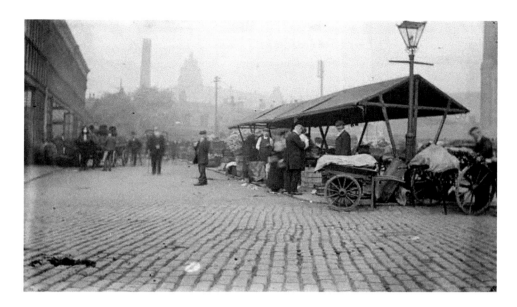

The Market, Crackenedge Lane, *c.* 1900

The covered market was an addition to the open market; it was not built to cover existing stalls. The structure was built in 1898, after Dewsbury Council had compulsorily purchased the site in the mid-1890s. This was previously the works and houses belonging to James Austin & Sons, steelwork manufacturers. Looking for new premises, James Austin moved across the road to a vacant site, where again he was compulsorily purchased in 1935 by the Lou Morris chain that eventually built the Playhouse Cinema. The glazed link to join the open markets was erected several years later.

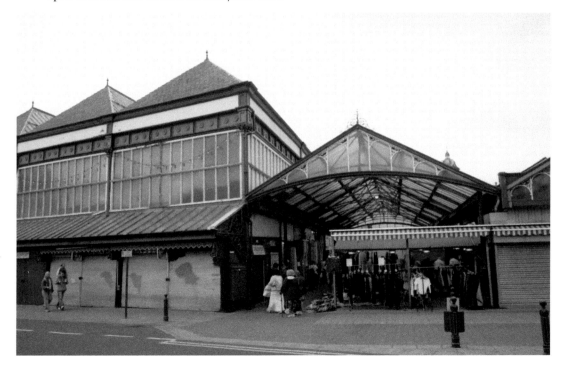

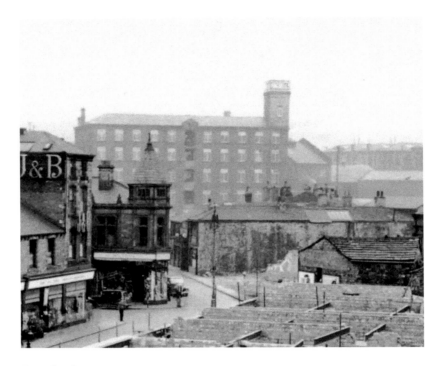

Foundry Street, 1937

The large six-storey mill was that of Machell Brothers Ltd, and was characteristic of the many mills that existed in Dewsbury over the years. This one remains, but is now divided into flats with a shop below. The tower with the name on would have once been water storage, providing a head of water for the mill; the tank has now gone and been replaced with a new roof. The full name of the mill, 'Machell Brothers Shoddy & Mungo Manufacturers', has been retained on the other side. Today, the mill forms a wonderful backdrop to the bustling market.

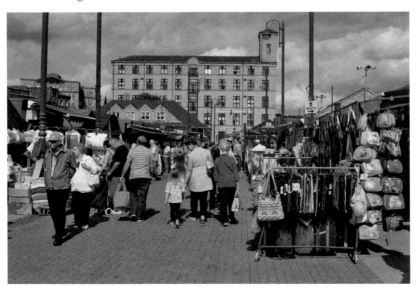

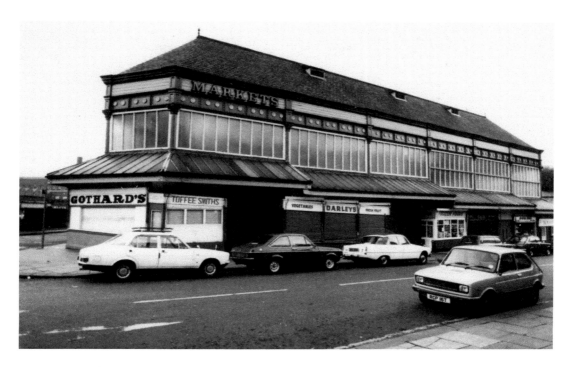

Corporation Street, 1979

The covered market originally had a glazed roof and clerestory lighting. Constructed from cast iron and glass, this was modelled on a similar grid system used by Joseph Paxton to build the greenhouses at Chatsworth House and the Crystal Palace. The glazed roof area was difficult to maintain and was subsequently replaced with a slate roof in a refurbishment programme. Gothard's closed its stall recently; this was a traditional stall selling many varieties of tripe, one of the few shops selling nothing but tripe in the country.

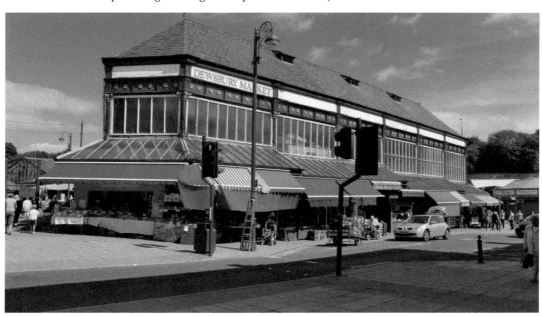

Foundry Street, 1979

This is the west side of Broadway House, which did not exist until 1937. Prior to this date, it was a very dark, narrow street, less than 12 feet wide. Broadway House opened the area up. Various shops have come and gone, but none ever seem to stay very long. However, the modern addition shown in the picture was part of the Silvio's Bakery group for many years. They produced various breads and delicious cakes and these, along with the first-floor cafeteria, were much loved by the Dewsbury locals. Today, it is a pedestrian area with seating and planting.

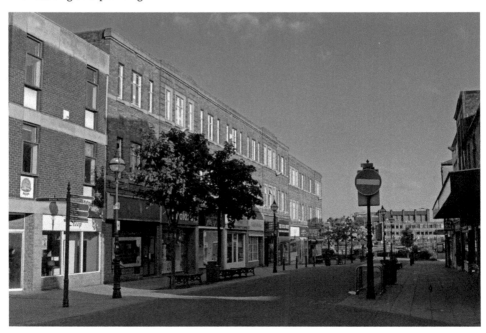

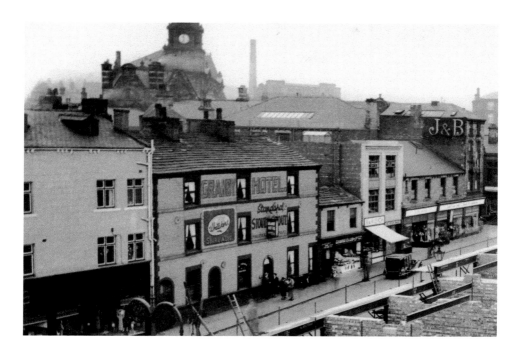

Foundry Street, 1937

On the other side were larger shops. Going along the line was the Batley firm of Jessop's Tailors, the Granby public house, fish merchants Herman Pickles (who smoked herrings near the station), a hairdresser above a butchers, and, finally, another site of J&B's. The latter was a large corner site that would stay in the minds of younger children. Prior to Christmas, it was where J&B's used to bring Santa Claus back to the shop and he would climb in through an upper-floor window. Today, it is a pedestrian area, and several of the premises have now become charity shops.

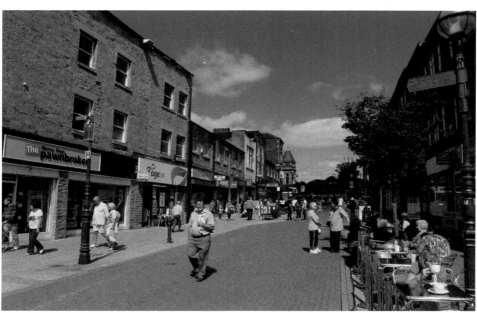

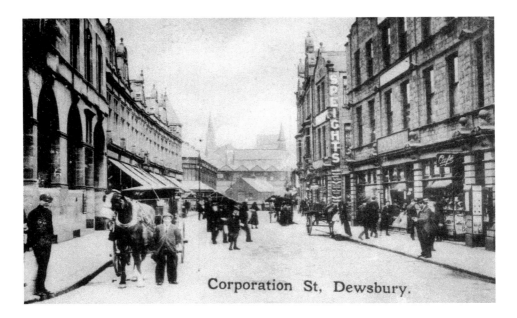

Corporation St, Dewsbury.

Corporation Street, *c.* 1900

Formerly called New Bridge Street, the street was renamed Corporation Street after Dewsbury Council had built shops and offices as a speculative development. Both sides of the premises were fully let and it formed a busy shopping area. The near left-hand corner was the National Westminster Bank and the far right-hand corner was the other corner of J&B's. This street had a wonderful end view: the high level part of the Great Northern Station, the roof and tower of Eastborough School and the spire of St Philip's church, Leeds Road, now demolished.

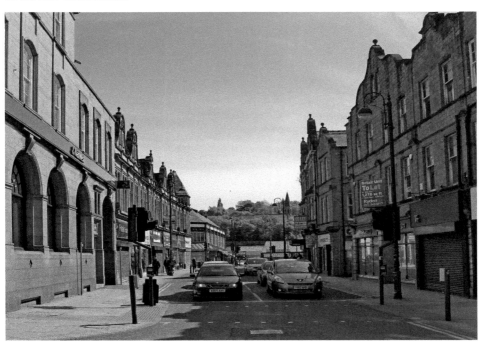

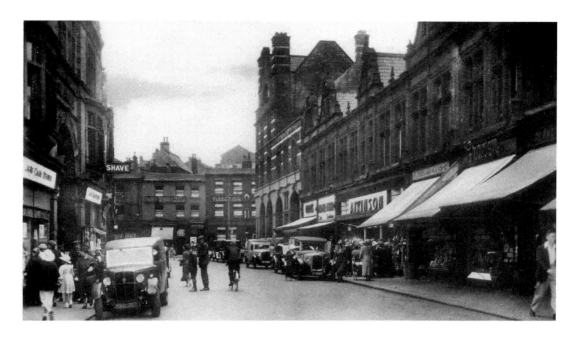

Corporation Street, *c.* 1938

Looking back towards Northgate. On the right is the top end of the arcade. Beyond that, everyone will remember the side entrance into Woolworths, a useful shortcut. However, when the store became self-service, this access had to be abandoned. The buildings at the end of the street included the Fleece Inn, a busy Tetley's public house, and Halstead's tobacconists. These were demolished in 1962 and the new building appeared in 1964. These included the Army Stores and the Monte Carlo coffee bar. Coffee bars were new meeting places for the younger generation.

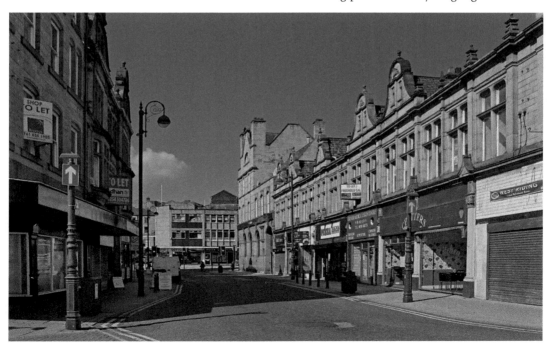

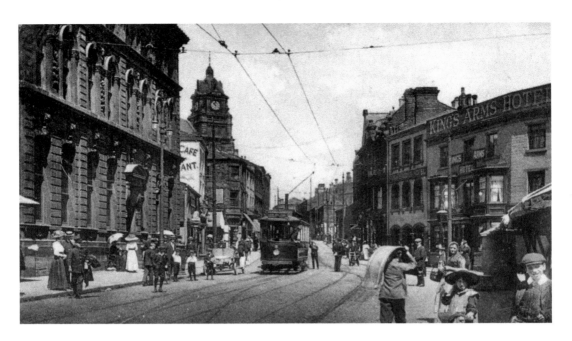

Northgate, *c.* 1910

This was at the very heart of the town centre, suffering from evidence of smoke pollution. Here were public houses, shops, banks and transport, and the departure point of many of the tram services. Pictured here is the tram bound for Ravensthorpe, a single-decker capable of negotiating the low bridges. The clock tower is the pinnacle of the Dewsbury Pioneers Industrial Society building, situated on top of the cinema. Two of the largest public houses sit next to each other: the Man and Saddle and the King's Arms Hotel, opposite the White Horse. The Black Bull is just out of picture.

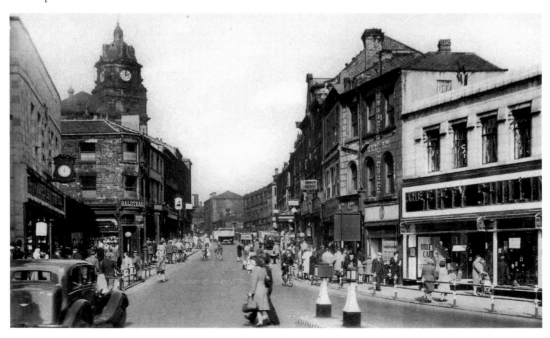

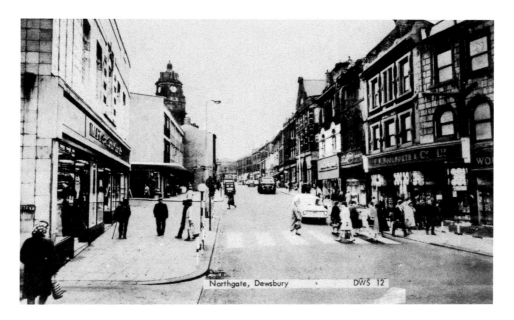

Northgate, *c.* 1970

This continued to be a bustling part of the town. However, three of the public houses have disappeared and only the Black Bull remains. Seen above Woolworths are the façades of the former public houses. Replacing them are new shops: Marks & Spencer on the left, Woolworths on the right, and WHSmith further along. These were the keynote shops that generated the life of any town. The up-to-date picture shows the trend towards a more pedestrian-friendly town. The HSBC Bank and the Pioneers' Building have had all the smoke and grime of 100 years removed.

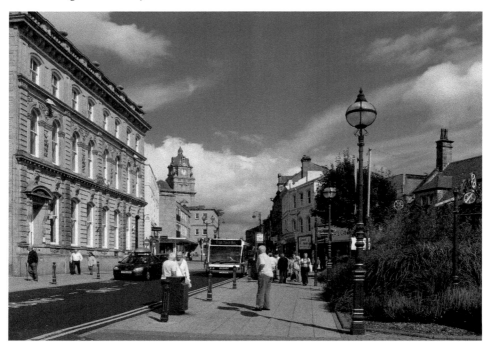

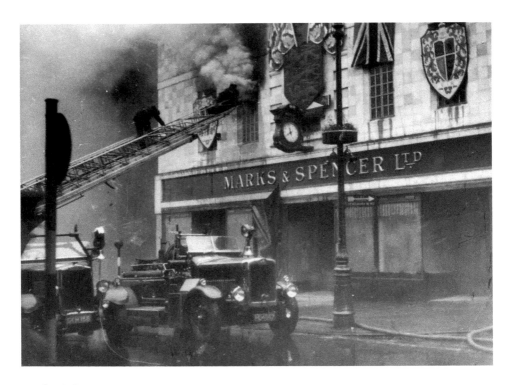

Marks & Spencer, 1953

On 3 June 1953, the shop suffered a catastrophic fire, which gutted the building. It was the day after the Coronation of Queen Elizabeth II, which may have contributed to the fire. There were celebratory plaques and illuminated decorations fixed to the front of the building. It was rumoured that an electrical fault in the wiring taken from the first floor caused the fire; the decorations over the windows meant that the flames from the fire were not seen straight away. Marks & Spencer chose to move from Dewsbury and the building was taken over by Peacocks.

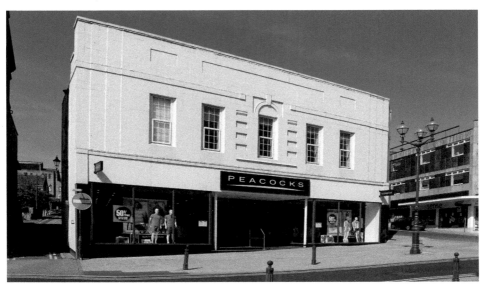

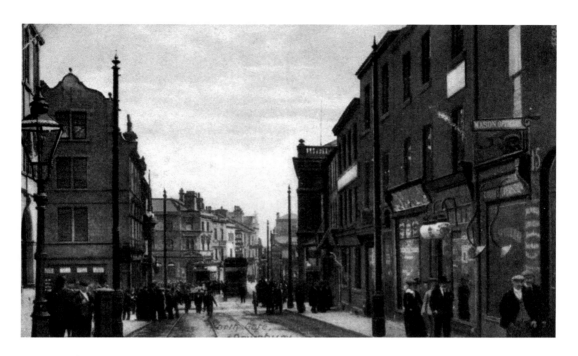

Northgate, *c.* 1910

Here we look down towards the market place, still as busy as ever, with people mingling with the trams. The old picture is a tinted card and makes the building appear as brickwork; in fact, all these buildings are natural stone. On the right is the Fleece Inn (*mentioned on p. 27*) when looking along Corporation Street. The modern view appears much wider and certainly lighter. The Fleece Inn has gone and has been substituted by another drinks establishment, the Time Piece. Otherwise, most of the other buildings remain the same.

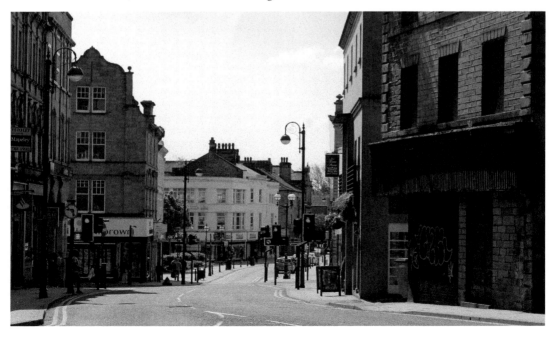

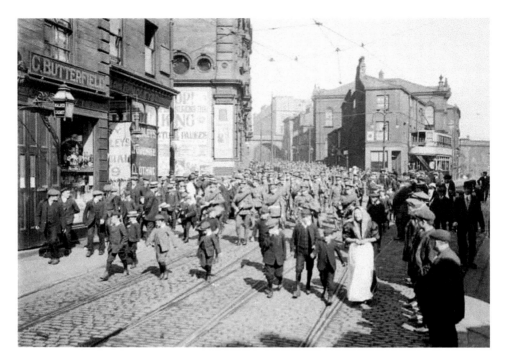

Northgate, *c.* 1910

Looking up towards Halifax Road, we see a military procession marching into the town centre. On the left can be seen the corner of the Pioneer Building, which was the access into the Pioneers Cinema. In the middle distance is the 'Flat Iron' site, and beyond that is the huge outline of the Salem Methodist church, leading to the single visible arch of the railway viaduct on the Manchester to Leeds line. The new picture shows the Art Deco style building that was once the Gas Showrooms. The continuation of the viaduct can be seen crossing Bradford Road.

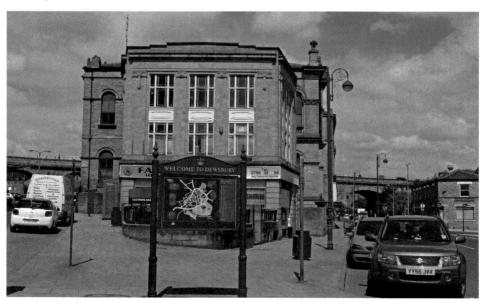

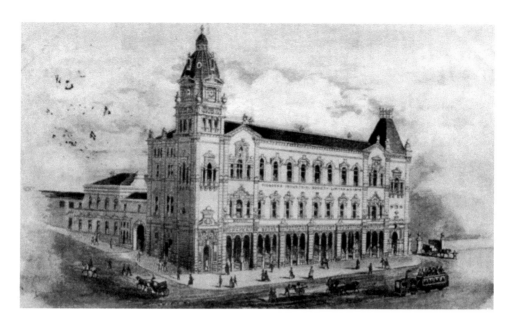

Dewsbury Pioneers Industrial Society Headquarters, Northgate, 1876
An architect's impression of the first phase of the building. The foundation stone was laid on 14 September 1878 and officially opened on 11 December 1880. It took only two years to build, at a cost of £37,000. The new building included a 1,500-seat industrial hall, reading rooms and a cinema, over seven shops at ground-floor level. Further extensions took place in 1896 and again in 1914 to create a large café and banking hall. After several owners and many years of stop-start alterations, the building is now being renovated by Kirklees Council.

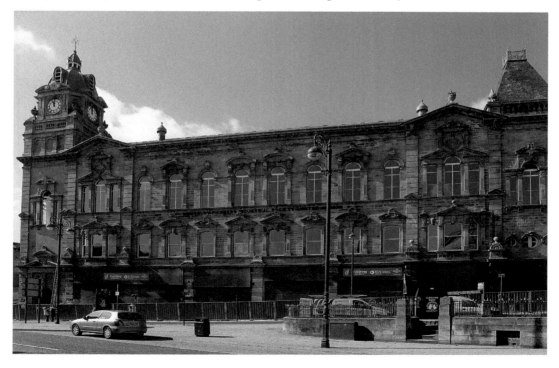

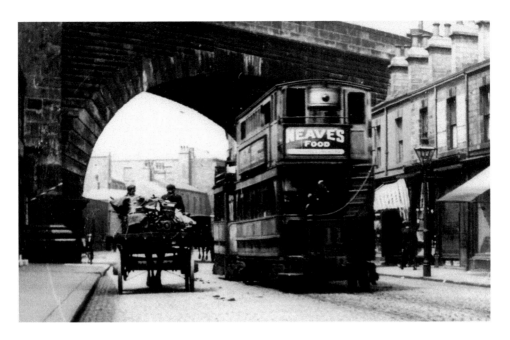

Bradford Road, *c.* 1900
Leaving the town centre and approaching the railway viaduct is a Merryweather steam tram loco, hauling a double-decker trailer, one of three built in 1886 by the Ashbury Carriage & Iron Co. Ltd of Manchester, which would be going to Gomersal. The new picture shows the same viaduct, with modern public transport.

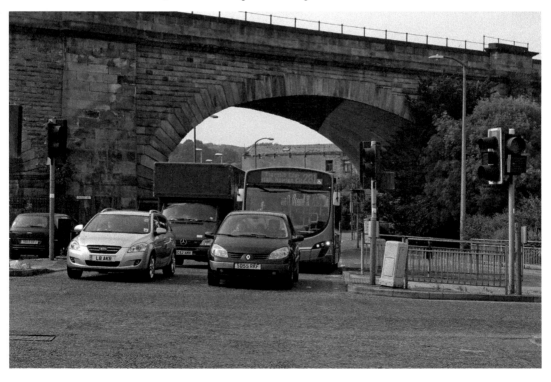

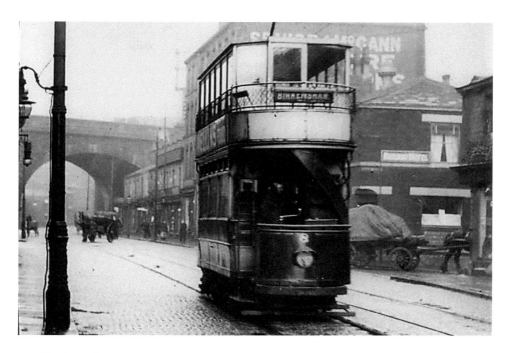

Bradford Road, *c.* 1910

Outside Salem chapel is electric tram No. 8, travelling along Bradford Road via Birstall on to Birkenshaw. This is the second of forty-two cars built in 1902/03 by Brush Electrical Engineering Co. Ltd, Loughborough. They were bought to expand the system, and they later took over from the steam trams in 1905 and were withdrawn in 1934. In the background is the Railway Hotel, later named Tapps, and subsequently closed.

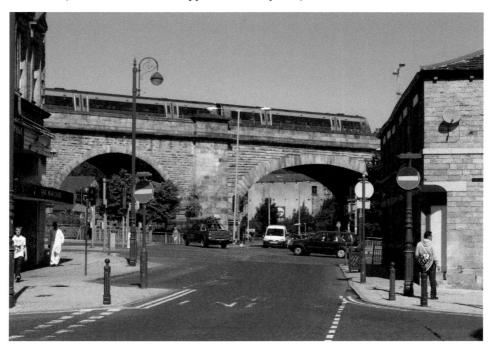

Park Street, *c.* 1930

Situated off Crackenedge Lane, the view down the street consists mainly of workers' housing close to the town centre. The tower to the right-hand side of the picture belongs to Bullocks Confectioner's of Bradford Street. The tall chimney in the centre of the picture still exists, although it is now shorter, and is the only one of its type to remain in the centre of the town. However, a new high point has appeared in the form of Emley Moor mast on the horizon.

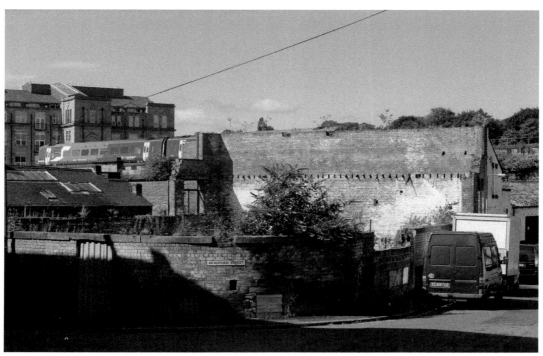

END of the line for the fire-wrecked factory believe to have given Blackpool the first taste of its famous rock.

Bradford Street, *c.* **1970**

The former premises that belonged to Bullock's Confectioner Ben Bullock, a sugar boiler who owned his own factory in Dewsbury. He returned from a holiday in Blackpool in 1887 and made the first batch of 'rock'. When the idea occurred to him, or was suggested to him, that he should put 'Blackpool Rock' through the centre of the rock, he no doubt thought it was worth a try! The rest is history. Blackpool started to produce its own rock in 1902. After two fires, the premises finally burnt down in the 1990s; all that is left are the perimeter walls.

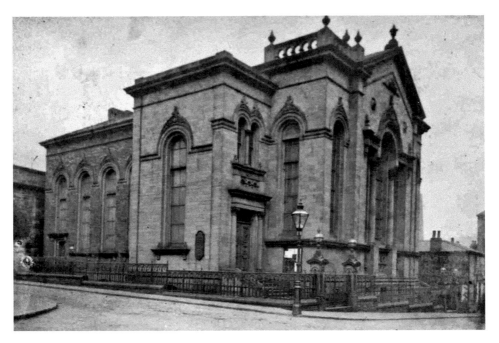

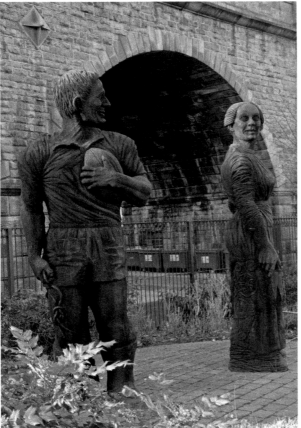

Trinity Methodist Chapel,
c. 1890
On the corner of Halifax
Road and Wellington Road
was one of the best attended
chapels in Dewsbury. As
attendances declined in
the 1940s, it closed and
reopened as the Majestic
Cinema. In 1949, it was
completely renovated at a
cost of £20,000 and renamed
the Rex Cinema. It was
one of the first cinemas in
Dewsbury to open on Sunday
nights, showing such classic
films as *Saturday Night and
Sunday Morning* and *This
Sporting Life* in the early
1960s. Two life-size statues
now stand there, depicting a
Rugby League player and a
female millworker.

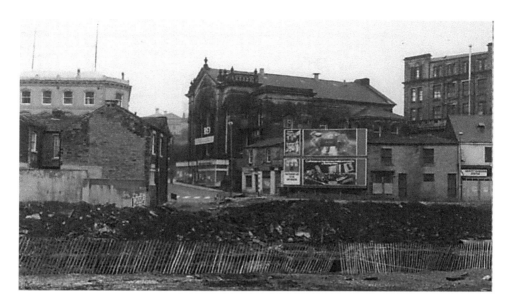

Bradford Road, *c.* 1970

This view shows the location of the chapel prior to demolition. It stood in front of the London & North Western Railway viaduct, carrying the Manchester to Leeds line. The viaduct spanned the Halifax and Bradford roads. Mark Oldroyd's mill stood behind, with Bicker's Department Store to the front. The chapel's position obliterated many of the central arches of the viaduct. However, when it was demolished in the 1970s, the new view opened up the whole vista, creating a stunning view of the whole viaduct and Mark Oldroyd's mill, both having undergone a major cleaning operation.

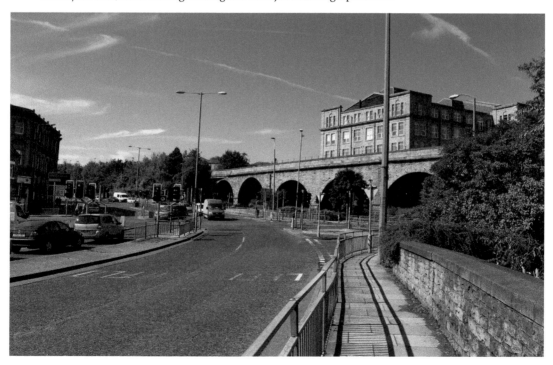

Wellington Road, 1968

This is a view of the massive stone structure that was the London & North Western Railway goods storage warehouse, adjacent to Wellington Road railway station. They would have stored all types of goods, but it would mainly have been material connected with the then thriving shoddy trade of the area. In the latter part of the nineteenth century, the 'Shoddy triangle', made up of Dewsbury, Batley and Heckmondwike, was producing 70 per cent of the world's shoddy. So recycling is nothing new! The ring road project opened up Wellington Road, allowing dramatic views of the former auction houses on the opposite side of the road.

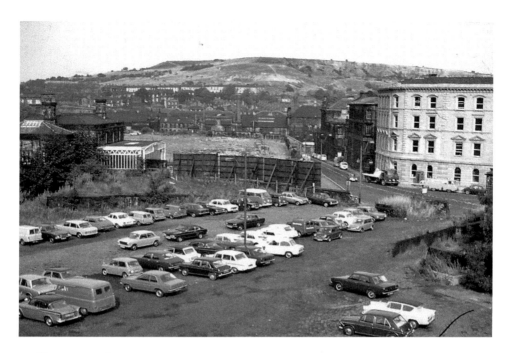

Wellington Road, *c.* 1970

This view overlooks a vast area of the town, as far as Caulms Wood on the hillside. Wellington Road station is in the foreground, with a rather haphazard car park. In the middle distance is the land vacated by the demolition of the goods warehouse, the former size being evident. Now the station has had improvements and the car parking has been formerly set out on both sides of the station. A TransPennine train from Manchester Airport to Middlesbrough pauses at the station. The building situated high up to the left is the former Dewsbury County Courthouse.

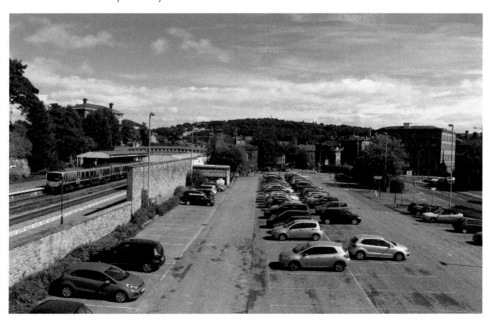

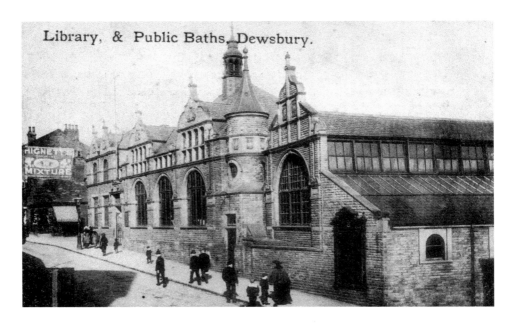

Library, & Public Baths, Dewsbury.

Wellington Road, *c.* 1910

This was the upper part of the road that the 1980s ring road left isolated, and therefore is now very quiet. Built on the corner of Wheelwright Street, opposite the site of the first Dewsbury Wheelwright Grammar School, was the library and public baths, built by Dewsbury Corporation in the late nineteenth century. The substantial baths had first- and second-class pools, as well as Turkish baths and a slipper room. Everyone will remember Mr Grimes, the school swimming instructor. The library has been sold for development and the baths are now a squash club.

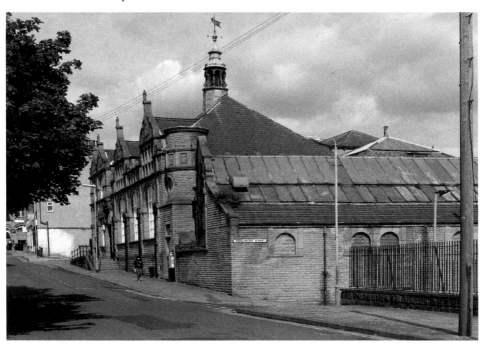

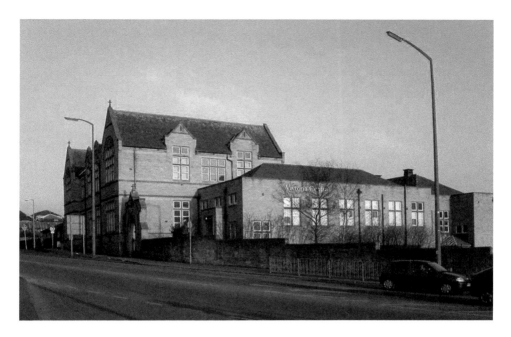

Wellington Road, *c.* 1990

Here we see the Victoria Secondary School, designed by architect G. A. Fox. The building was substantial, and despite the local authority's attempts to make use of it as office space, this failed because of its difficult layout and awkward room sizes. Despite many protests that the building should be retained, it was demolished in the early 2000s to make way for a new health centre. This was completed around 2006, and to mark the memory of the school, parts of the boys' and girls' entrance archways of carved stone were retained within the car park.

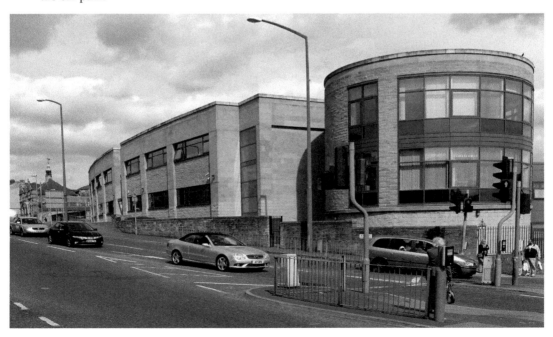

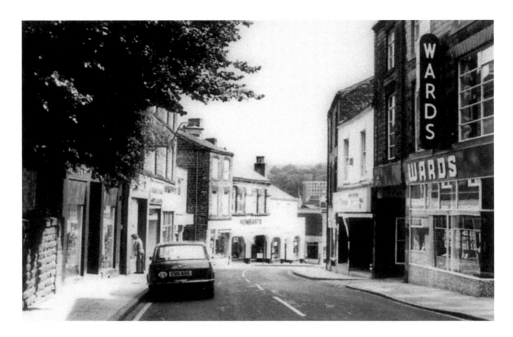

Daisy Hill, 1979

This view shows the upper section of Daisy Hill. The area was one of the busiest shopping areas of the town, where many prestigious shops were situated, including Wards Furnishers, Hombart's, and a wonderful model shop on the top left – it even had a dolls' hospital! The trees to the left are the grounds of the former Central Methodist church, built in 1846 in a very simple Georgian style. This was to celebrate the visits of John Wesley. Few of the buildings have changed, although the shops seem to have made way for estate agents' and solicitors' offices.

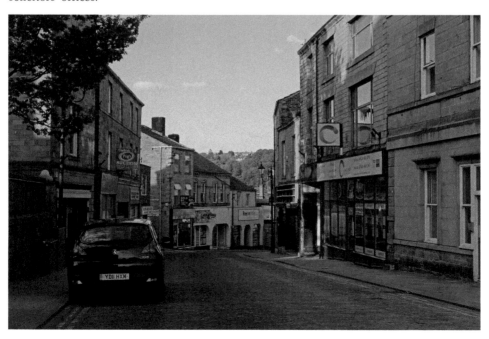

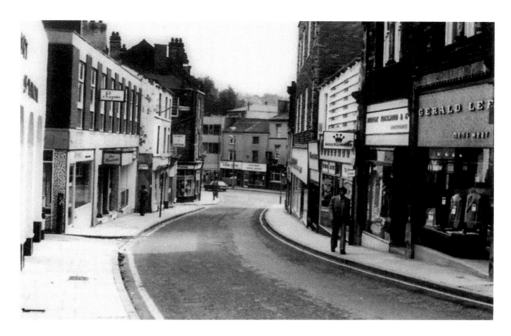

Daisy Hill, 1979

Further down the road, we can see Gerald Lee, men's outfitters, certainly the place to go for evening dress hire and top-quality menswear. Below was Hodgson's Department Store, selling everything from hardware to fashion. Things have changed here and are now somewhat run down. The many shops to let are a sad sign of the times. Daisy Hill has become the forgotten part of Dewsbury. In the early 2000s, the whole length of the road was re-cobbled with new stone setts, which were unfortunately ruined by the double yellow lines.

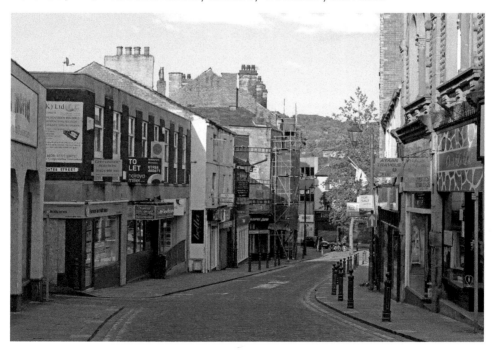

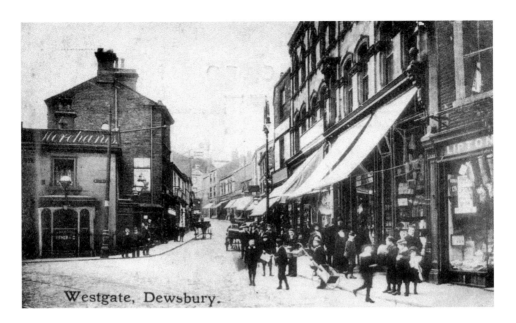

Westgate, Dewsbury.

Daisy Hill, *c.* 1910

The lower section shows how busy the area once was; by the evidence of the canopies, it appears that every shop is in use. These were usually food and grocery stores, with the awnings creating shade. To the right were two notable businesses, Wrigglesworth's, renowned for its china, fancy goods and knitting wools, and Talbot's Ironmongers, everything you could ever require in the hardware department. Their advert was a huge circular-saw blade, fixed to the outside of the building. To the left was the Fryers Vaults, so named because the landlord used to dress in clerical dress.

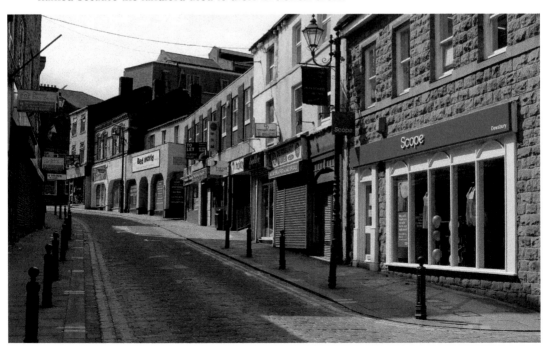

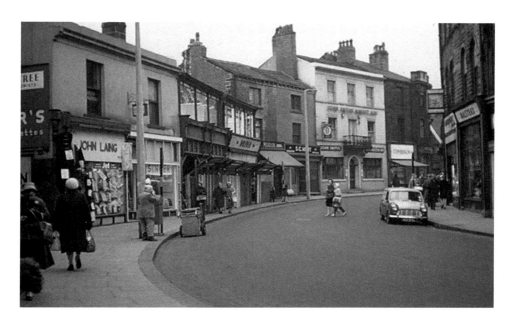

Westgate, 1962

Looking from the Market Place towards Daisy Hill, we see another busy little cluster of shops, including John Laing's outfitters and the Singer sewing machine shop next door. The step still retains the letter 'S' in mosaic. Following around, the Duke of Wellington Hotel is where council meetings were held prior to the construction of the town hall. The little coffee-and-cream-coloured minivan belonged to J. W. Thornes Ltd, supplying televisions, electrical goods and vinyl records in the 1960s. They even had little booths where you could listen to the records before buying. Driver's grocery store is really the only thing that has changed.

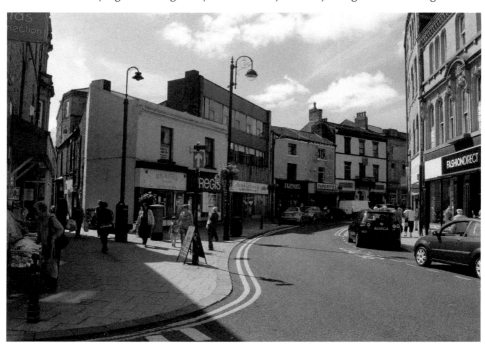

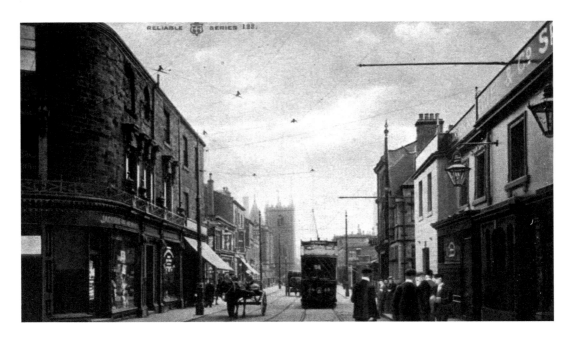

Church Street, c. 1910

This is a striking street scene. Many varied shops and businesses connected Daisy Hill to the parish church, forming a pleasant backdrop to the view. We can see the Fryers Vaults again, originally owned by Solomon Hindle from 1790 and called Hindle's Spirit Vaults, then Beckett's Vaults in 1850. From 1970, it was owned by William Fryer, one of the town's two constables. It was closed and demolished in 1960. We can see old and new transport with the horse-drawn carts and a tram. Much of this has gone and newer buildings have taken their place.

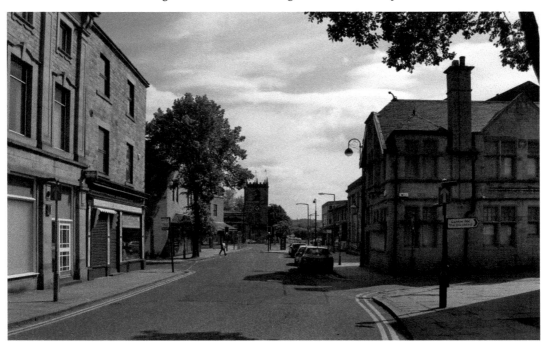

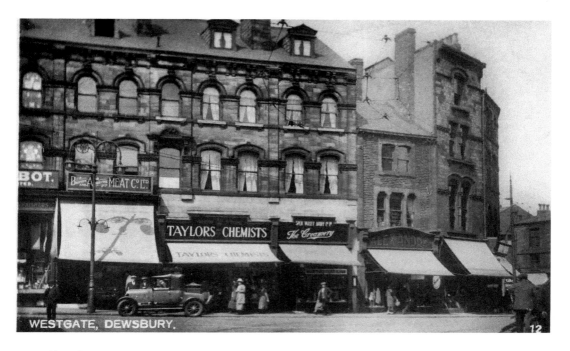

WESTGATE, DEWSBURY. 12

Church Street, *c.* 1930

Looking back in the other direction, we have two views in the 1930s and 1970s. The imposing shops and offices are at the start of Westgate. There are striking shopfronts, such as Taylors Chemists, prior to the merger to the more well-known Timothy Whites & Taylors. The large blinds indicate food shops, such as the Creamery and the Meat Co. Ltd. The first floor of the building was a restaurant in the 1970s, Trader Jack's, owned by local businessman Jack Ridley. The newer picture shows most of the buildings that were demolished for the new shopping centre.

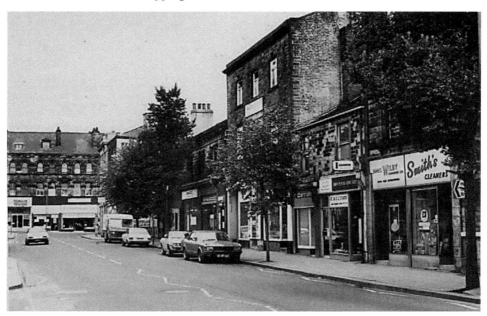

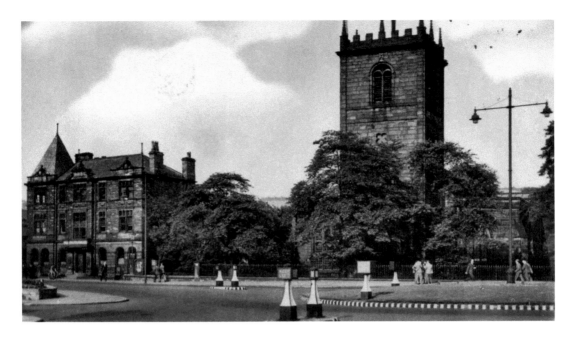

Aldam's Road, *c.* 1950

A view of the parish church and Elm House, the roundabout and road system having completely changed. Elm House was offices for many local businesses, but became redundant and was demolished in 1961 to make way for road-widening. The new ring road now passes by the front of the church, the grimy stonework being cleaned to expose the attractive coloured stone that was extracted from the local Caulms Wood Quarry. The church was later upgraded in status to a Minster in 1993. For the last 700 years, the 'Devil's Knell' has been rung here on Christmas Eve. The rear wall of the shopping centre can now be seen on the left.

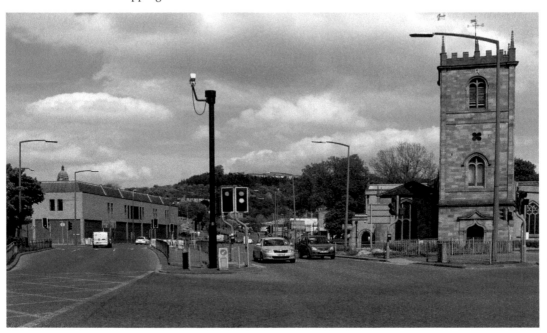

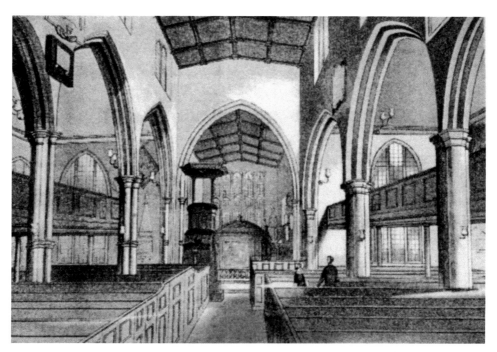

Dewsbury Parish Church, c. 1850
In 1767, John Carr rebuilt
the north and south aisles of
the church, and installed the
balconies. In 1884–87, the
medieval chancel was demolished
and a new east end was built to
the designs of G. E. Street. In
1895, the south aisle was rebuilt
in a 'more seemly Gothic style',
and the balconies removed. In
1993, the east end was reordered
and the altar moved to the west
end of the church.

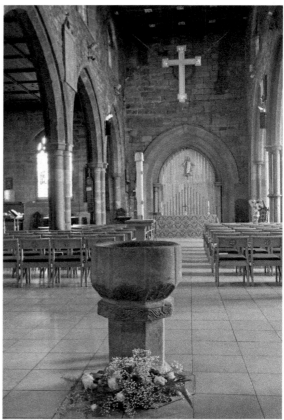

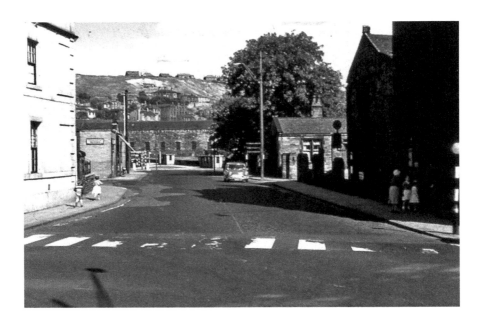

Vicarage Road, 1961

We move around the parish church, towards the town centre. The entrance to the bus station appears on the left, followed by Long Causeway towards the town hall. Straight ahead is the huge side wall of the Lancashire & Yorkshire Railway company goods sheds. To the right, by the red mini, stands the Moot Hall, built in the grounds of the church in 1270. Around 692 years later, in 1962, Dewsbury Council decided to demolish this to make way for the ring road. Planning legislation to protect ancient buildings was not introduced until the end of the 1960s.

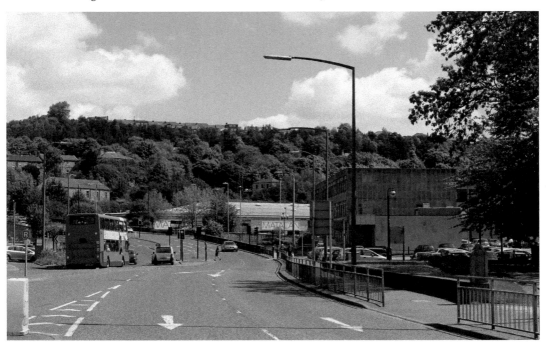

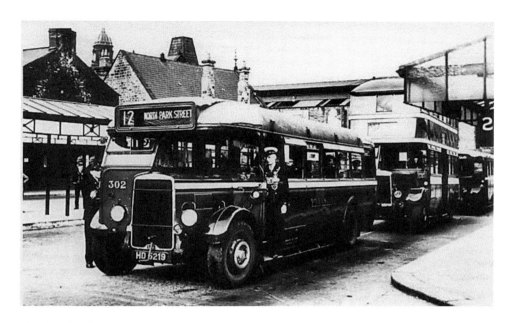

The Bus Station, *c.* **1935**
Situated off Vicarage Road, this was the hub of the bus services of Yorkshire Woollen District Transport Company Ltd. As they were very protective of its property and not allowing private operators to use the stopping points, they were forced to use other stops such as Rishworth Road and Long Causeway. In the background is the Masonic Hall and the roof of the then closed market place railway station. This was replaced by a modern transport interchange, built 150 metres away, along Aldams Road. Towering above the interchange is the former Yorkshire Building Society headquarters, now redundant.

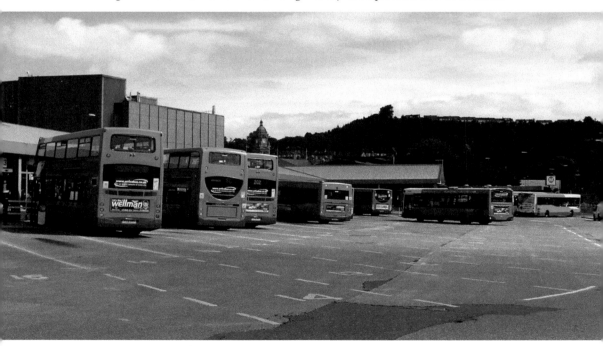

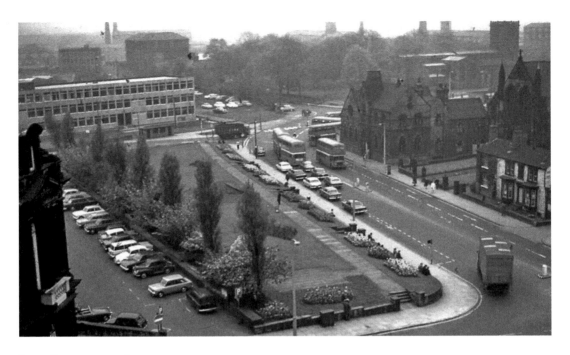

Long Causeway, 1962
Looking over the gardens, this was formerly the site of the Lancashire & Yorkshire railway station, which was closed in 1930 and demolished around 1937. Then the whole site had a concrete roof added to form an air-raid shelter for use during the Second World War – it is still there! The dirty building to the centre is the Masonic Hall, with the United Reform church alongside. Under construction in the centre is the new DHSS centre for Dewsbury. To the side, cars are parked on the site for the new public swimming baths, built in the early 1970s.

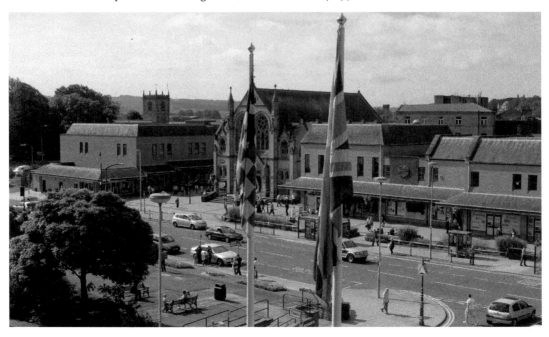

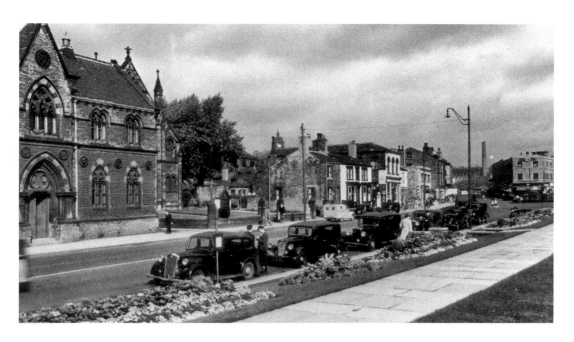

Long Causeway, c. 1950

The United Reform church is hidden behind the imposing building that is the Masonic Hall. By 1950 its days were numbered, and once demolished it opened up the area around the church. For many years, Long Causeway was the site of the town taxi rank. In the 1950s, money was scarce and as taxis were not the most economic form of transport, the bus station opposite was the preferred option. All the other properties were removed to build new shops. The later picture shows the Olympic torch being carried along Long Causeway, prior to the 2012 London Olympics.

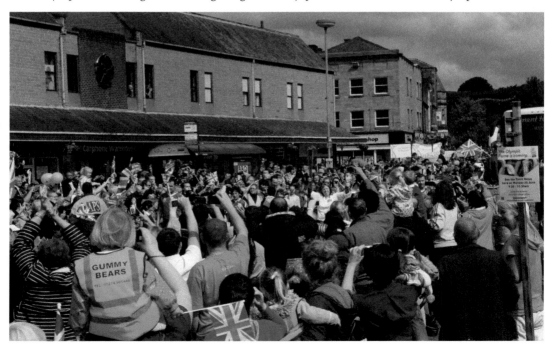

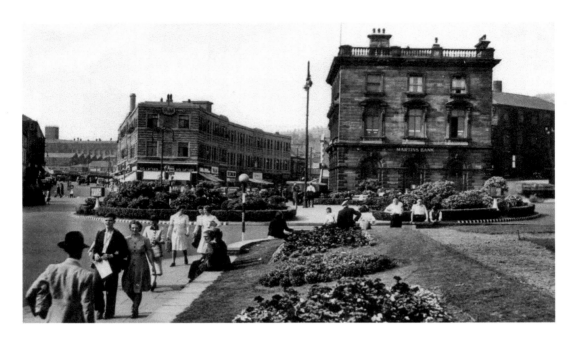

Long Causeway, c. 1950

The long view, overlooking the gardens towards the town centre; taking pride of place are Broadway House and Martins Bank, both looking quite splendid. Broadway House displays the Weaver to Wearer sign and Pearson & Moody (P&M) offices on the upper level. P&M were a large company, delivering coal and coke, working from depots in Thornhill Lees. To the far left is the tower and large rear wall of Bullocks Confectioner's. The two former buildings are retained, while Martins Bank has changed to Barclays Bank, looking clean and quite majestic in the summer sun.

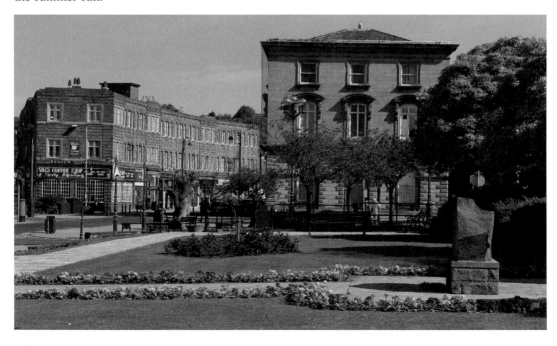

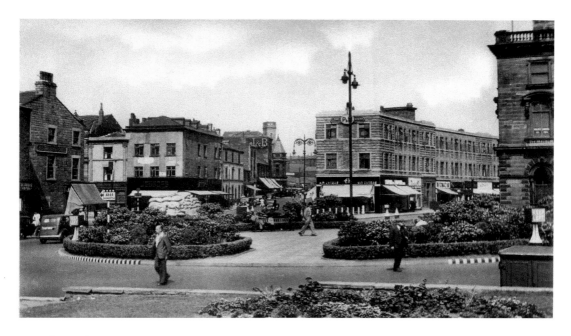

Town Centre, *c.* 1950

Another view along Long Causeway, looking over the roundabout towards market place. To the left is the Scarborough Hotel, scene of the 1915 tram crash, and to the centre, the rather drab building that was once J&B's. Looking further along Foundry Street, we can see the Granby PH and the current site of J&B's. The large structure visible in the centre is the water tower, attached to Machell's Mill. Today, the roundabout has gone, pedestrianised with seats and trees, and the building that was once J&B's has been now been caringly restored.

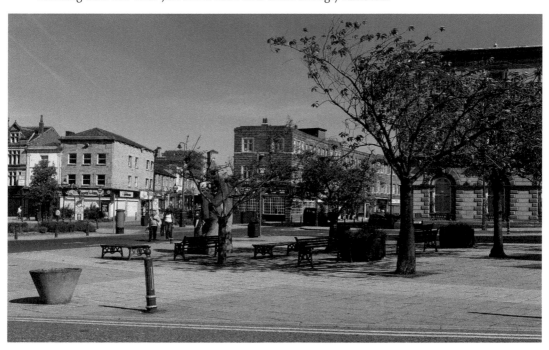

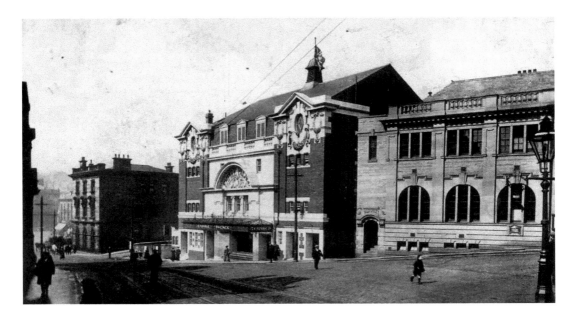

Wakefield Road, *c.* 1920

A majestic view of the Empire Theatre, built in 1909, where Dewsbury residents gained fond memories of going to see the likes of Charlie Chaplin, Harry Lauder, Gracie Fields and Stan Laurel. There were star-studded pantomimes every Christmas, too. The truth is that, due to a lack of support, the Empire only lasted forty-six years, finally closing in 1955; their patrons had discovered televisions! It remained empty for five years before demolition. Located above the Empire is the general post office and sorting office. Today, here stands Empire House, an office block completed in the early 1960s.

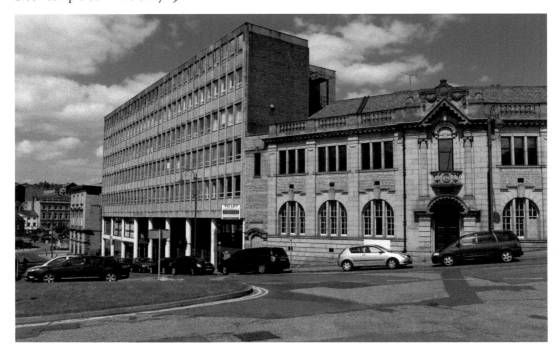

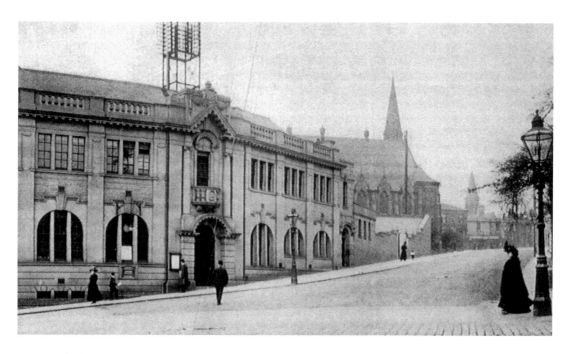

Wakefield Road, *c.* 1920

The main general post office and sorting office was a tough walk up the hill if you wanted to buy stamps or post letters! The yard to the top side allowed post office vehicles to enter the sorting office area. The style of building is classical, but trying to be Art Deco, a style that began to emerge in the late 1920s. The spire to the rear belongs to the Baptist church in Leeds Road, and the tower beyond that is Eastborough School, between Battye Street and Rockley Street. Both are still there today.

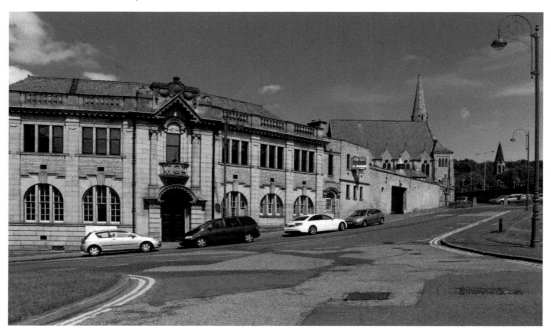

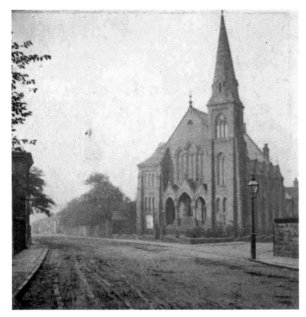

Leeds Road, *c.* 1880
Looking down the road towards the town centre is the commanding Baptist church, which opened on 7 December 1871, and was enlarged in 1923. It was built in the Gothic Revival style and listed in 1985. This is a very early picture, as the town hall has not yet appeared in the background and the church appears to be much further out of the town centre than it does today. The church was reordered internally around 2000.

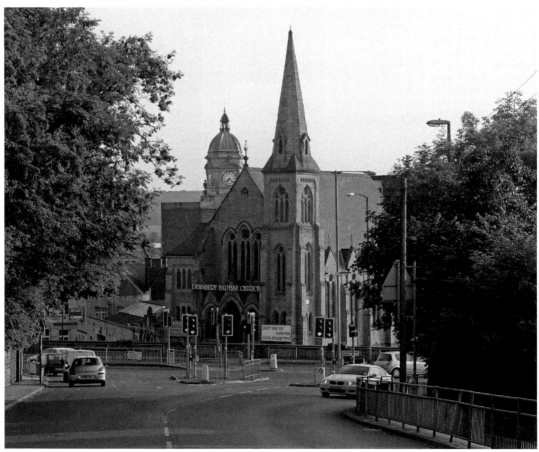

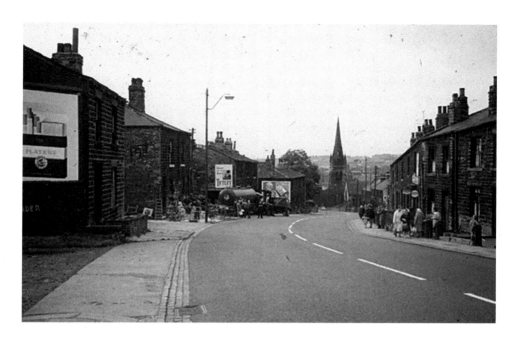

Leeds Road, 1961

Looking down into the town is St Philip's church. Although it was only opened in 1878, this church was closed and subsequently demolished in 1966. We can also see that a tanker has crashed into buildings halfway down the hill, which was a fairly frequent occurrence. Nowadays, trees obscure a large part of this view but, on the plus side, there haven't been any runaway lorries recently!

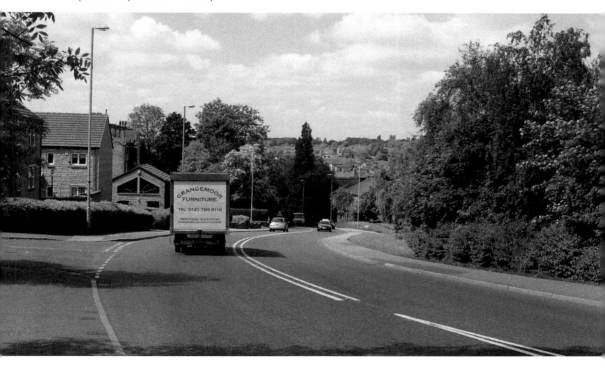

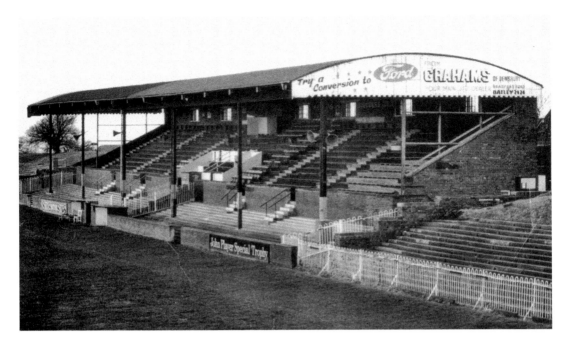

Crown Flatt, *c.* 1985

Dewsbury is a rugby town. Many stars of the game have emanated from the amateur clubs in the area. Dewsbury was the first club, along with Wigan, to play at Wembley, in the cup final of 1929. Its most successful years were during the Second World War, when Eddie Waring was the manager, and in 1973, when they won the Championship title. The stand, along with archives going back to 1875, was destroyed by arsonists in September 1988. The club left its famous Crown Flatt ground soon after and moved into its present stadium on Owl Lane in 1994.

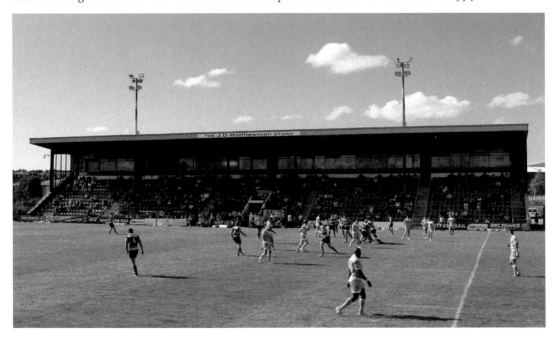

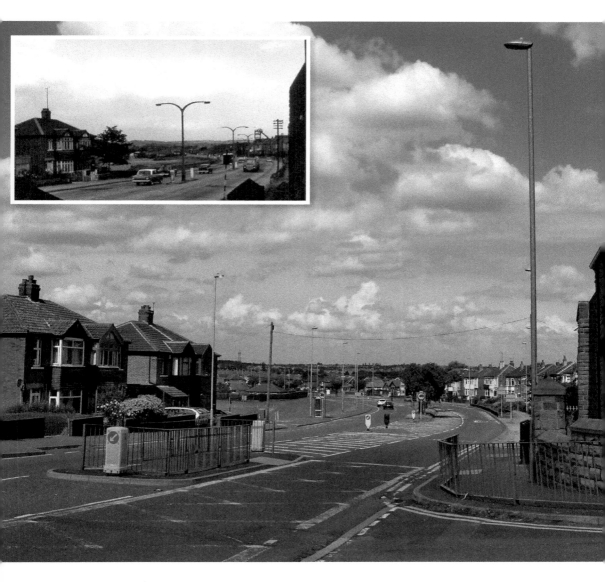

Leeds Road, Shaw Cross, 1965

The inset shows one of Dewsbury's first dual carriageways, heading out of town to Leeds. Note the typical 1960s arched concrete lamp standards on the central reservation. These had a very short lifespan. Interestingly, we can see the wheel and winding gear of a colliery at Chidswell to the right of the picture; these really are rarities and a thing of the past. Nearby Shaw Cross pit was one of the collieries that regularly mined a million tons of coal per year. Little has changed, with the exception of the new playing fields on the left of the modern photograph.

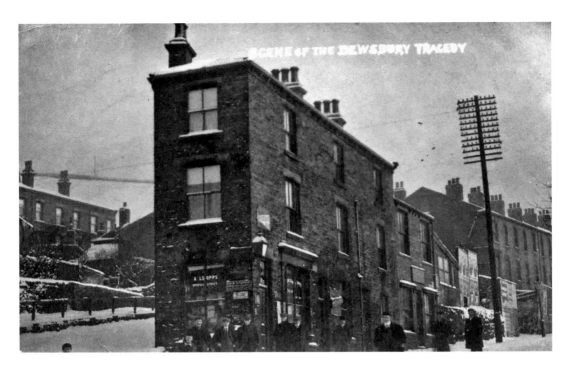

Old Bank Road, 1906

The picture refers to the 'Dewsbury Tragedy'. William Stadden, a Welshman, who came to play for Dewsbury rugby club in 1886, was the first Welsh player to be bought by an English club, and he evolved into a star player for both Yorkshire and Wales. However, on Christmas night 1906, with a lodger and his five children asleep in the house, he strangled his wife and attempted to slash his own throat. He died three days later. The large telegraph pole outside is unusual, as very few people would have had telephones in those days, and there is only one wire coming from it.

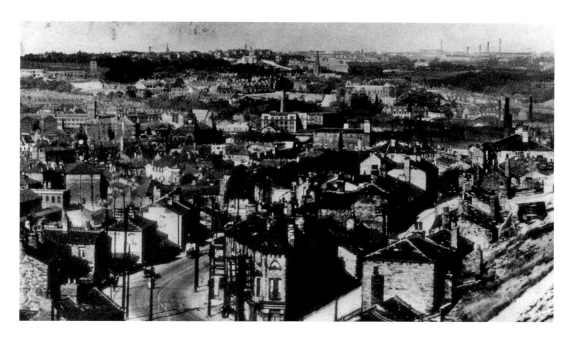

Wakefield Road, *c.* 1920

Looking down Wakefield Road, we see a general view over the town – a very grubby scene as a result from years of smoke pollution. From left to right, we can see the town hall clock tower, the clock tower of the Pioneers Building, the new mill of Mark Oldroyd, and the former infirmary, later the municipal buildings. On the horizon to the left are the mills of Staincliffe. Today's view has been completely engulfed by vegetation, but through the trees we see a town that appears much cleaner and fresher. All the mill chimneys have disappeared.

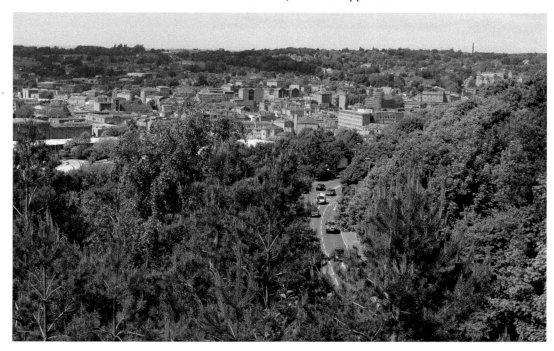

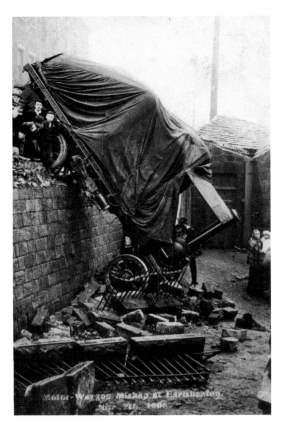

High Road, Earlsheaton, 1906
This is the junction between High Road
and Middle Road, and a commercial steam
wagon has crashed through the railings.
This occurred on 7 November 1906,
although it is not clear whether anyone
was killed or injured. Note the open cab
and solid rubber tyres on the wagon.
Today, the view is the same; more railing
has been added, but it does not look as
strong as the original railing at the side of
the van.

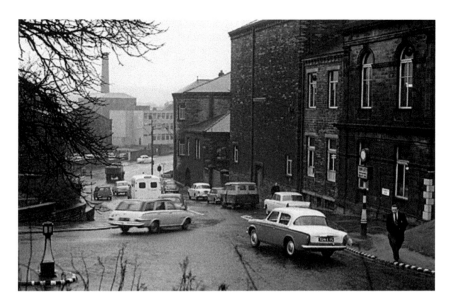

Rishworth Road, 1961

This is the rear of the town hall, looking down towards the DHSS building. This was without doubt the busiest junction in the town, where the Leeds and Wakefield roads merged with no traffic lights and no obvious right of way. This was the road down which many vehicles ran away and plunged into the town hall. We see typical cars of the period: a Vauxhall Victor estate and a Hillman Minx. The previously dirty town hall has now been cleaned. Once the new ring road was constructed, above the new retaining wall, this road became almost redundant, used only for access.

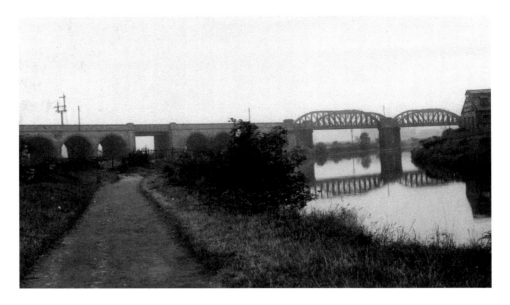

Sands Lane, *c.* 1910

Here we see the Great Northern Railway link to Thornhill Lees crossing the River Calder at Sands Lane. This line linked the vast goods yard and warehouses on Railway Street with the Lancashire & Yorkshire Railway main line. This line was closed for several decades, but was reinstated in 1964 following the closure of the line through Ossett. Closed again in the 1990s, it now forms part of the 'Greenway' cycle/walking route.

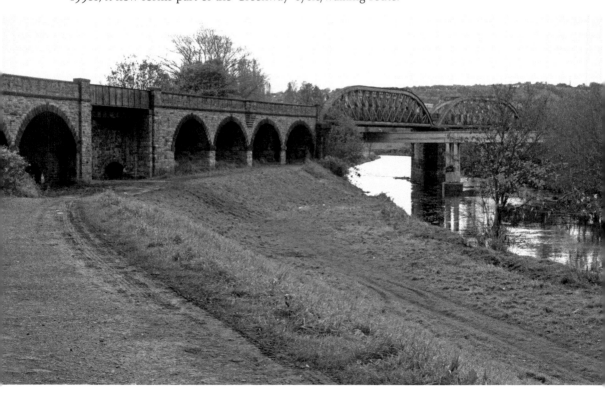

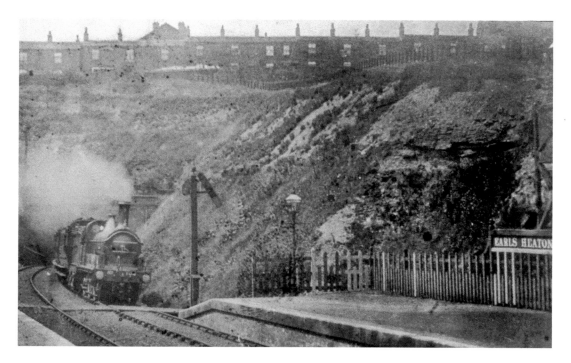

Earlsheaton Station, *c. 1890*

Situated on the Great Northern Railway Dewsbury deviation route, the line runs into Earls Heaton (*sic*) station, on its way from Dewsbury to Wakefield, before passing through Chickenley. Here, a passenger train emerges from the tunnel beneath Headland Lane. Earlsheaton had its own substantial station, goods yard and single loco shed. The station opened in January 1885 and closed in 1953. The buildings remained until the mid-1970s, before being demolished. The tunnel had been closed, but has now been restored with added lighting, and is now also part of the 'Greenway' network.

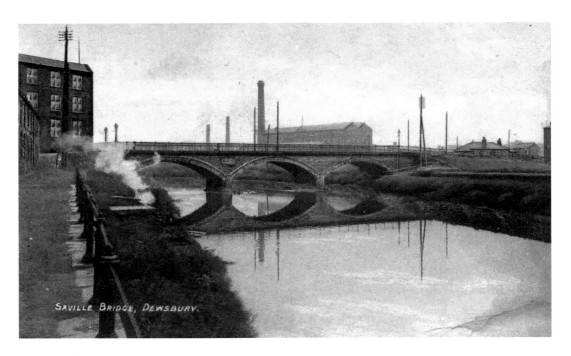

Savile Bridge, c. 1900

Spanning the River Calder, the Savile Bridge has been replaced several times. The three-arched stone bridge, built in 1862, was very narrow and larger vehicles struggled to pass each other. The bridge was replaced in 1936 with a much wider one, complete with lamps on the parapets. The large mill in the background is that of Sam Ellis. The low building to the right is the recently demolished Savile Hotel. The current bridge has only one span and has recently had major improvement works carried out. The banks were levelled and concreted over in the 1970s.

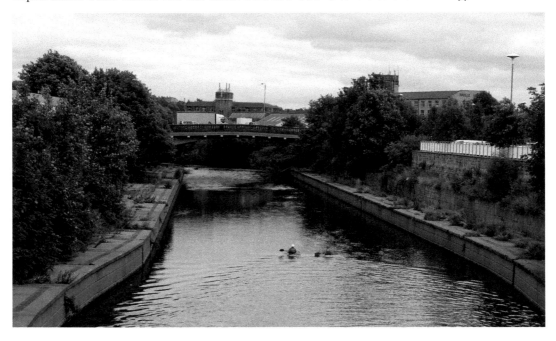

Canal Basin, *c.* 1950
These are the large series of timber warehouses, built in the mid- to late nineteenth century to load and offload goods at the Aire & Calder Company canal basin. The Calder and Hebble Navigation through Thornhill Lees was completed in the 1790s. This stretch had limited use, as it was effectively a terminus. At the other side of the yard, two-storey stone premises were built to stable eight horses with hay storage above; it is now the Legger's public house. The timber buildings were gradually removed during the 1980s to create car parking for the basin.

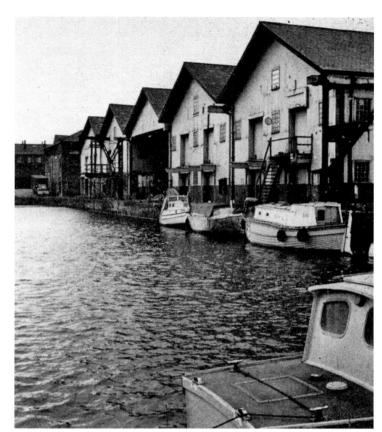

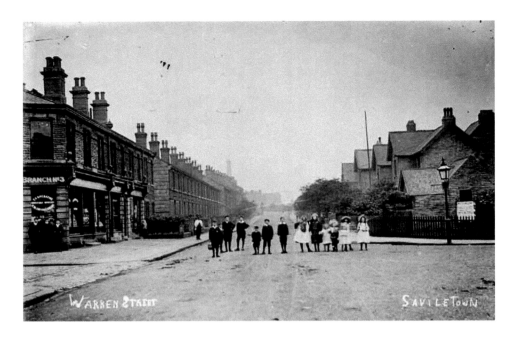

Warren Street, c. 1910

Warren Street is a busy main street running through the heart of Savile Town. All the houses were substantial stone dwellings. The ones fronting the main streets were mainly occupied by white collar staff, whereas the others were in tight-knit communities. Most were back-to-back, typical workers' housing, built to provide the local workforce for the mills emerging in the vicinity. Several shops, along with schools, churches and chapels, were integrated into the area. Savile Town now has a very diverse ethnic mix and the shops sell far different products to those of 100 years ago!

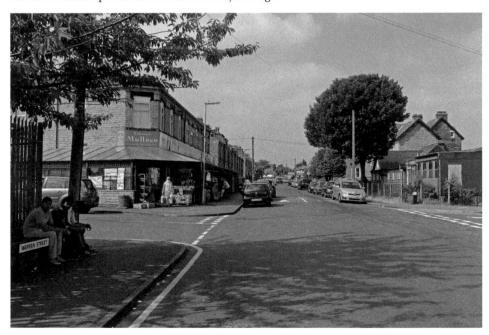

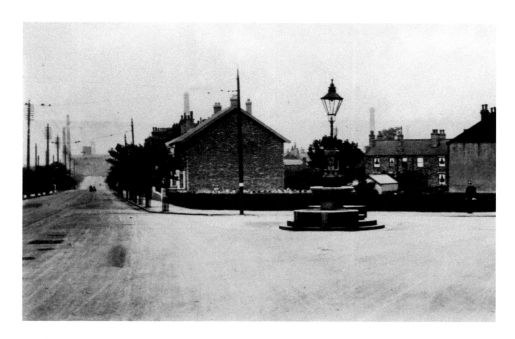

Savile Road, *c.* 1910

The area is named after the Savile family, who were the local landowners. This is the road from Thornhill and Savile Town into Dewsbury, relatively new and built as a turnpike road. The polished marble fountain in the foreground was placed there for the horse-drawn traffic, not humans. It fell into disrepair, but has now been carefully restored. When the road was initially built, it was lined with an avenue of young trees, which are now fully matured.

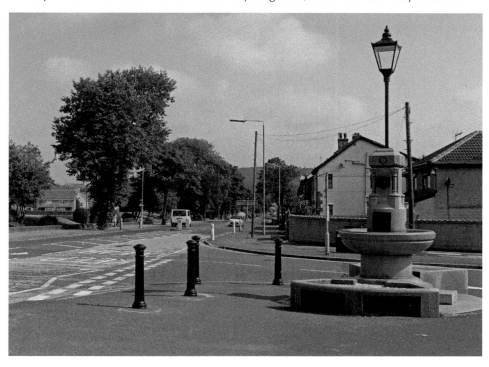

Savile Road, *c.* 1970

Here we see the local police trialling their first hand-held speed cameras on local motorists. In the background is Savile Town cricket and sports field, which had a bowling green at the rear The ground appears rather neglected here, despite its esteemed history. It was the venue for fifty-three Yorkshire County Cricket Club first-team matches between 1867 and 1933, including two matches against the touring Australians. The splendid pavilion seen in the distance was demolished in the 1990s. The area has been upgraded, with playing fields and children's play equipment.

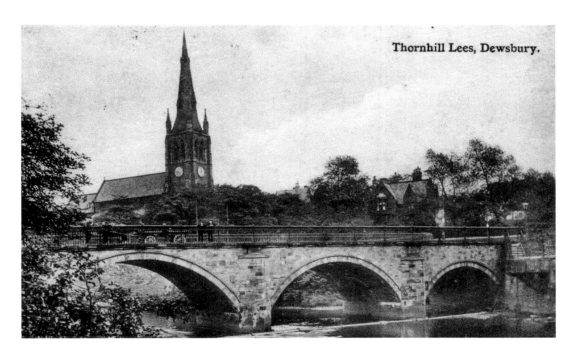

Thornhill Lees, Dewsbury.

Thornhill Road, c. 1910

Cleggford Bridge carries the road across the River Calder, many years ago the location of a ferry. The bridge was built in 1856 and secure handrails were added in 1889. It was completely restored, widened and strengthened in 2010, sympathetically keeping its Victorian appearance by using natural stone and cast-iron balustrades, painted in the period colours. Beyond the bridge is Thornhill Lees church, the church of the Holy Innocents, built in 1858. The church seemed to have closed in 2010, but now appears to be back in use. To the right is the vicarage attached to the church.

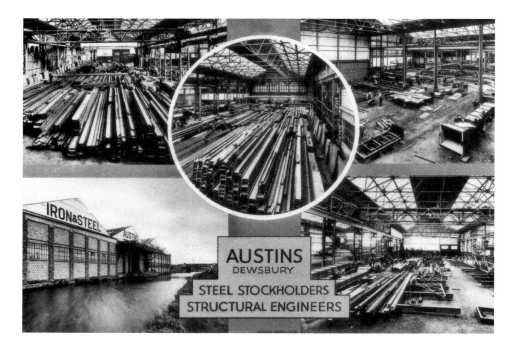

Austins Steelworks Advert, *c.* 1955

Two of the main employers in Thornhill Lees were James Austin and the Yorkshire Electric Transformer Company (YET). Austins began operations in the town centre and were early manufacturers of iron and steel goods for the textile trade, later providing structural steelwork throughout the whole of the world. The YET built large transformers for use in industrial locations, such as textiles mills and coal mines. The Calder & Hebble Navigation Cut ran past both premises. Here is the site of the former YET, now fast becoming an intensive housing site.

Kilner's Glassworks, c. 1920

This firm also employed hundreds of local people in the early part of the nineteenth century. The business on land off Brewery Lane started in the 1850s, and the firm was soon producing over 20,000 bottles per week. By 1890, production had gone up to 300,000 bottles per week; this is an indication of the number of workers required to run the business. Bottles were sent to London for storage and exported to all corners of the globe. Injunctions over pollution levels caused problems for the firm, which closed in 1937. Now the 11-acre site is housing and playing fields.

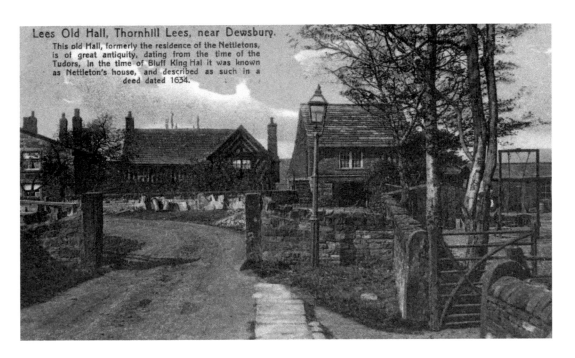

Lees Old Hall, Thornhill Lees, near Dewsbury.

This old Hall, formerly the residence of the Nettletons, is of great antiquity, dating from the time of the Tudors, In the time of Bluff King Hal it was known as Nettleton's house, and described as such in a deed dated 1634.

Lees Hall, 1911

The hall in Thornhill Lees was built around 1530, although parts are rumoured to date back much further, to Viking times. The structure is predominantly one big hall with smaller rooms off it, two storeys constructed from a timber frame with wattle-and-daub infill panels. There is a marvellous, coffered plaster ceiling and cornice at first-floor level. There is also a second hall built in the seventeenth century. It was surrounded by flat land, suitable for grazing animals. The smaller building to the right has suffered the ravages of time and has almost gone.

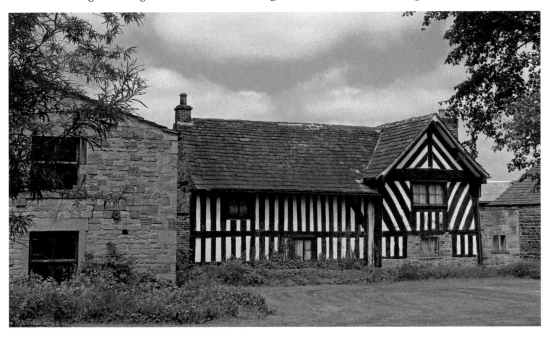

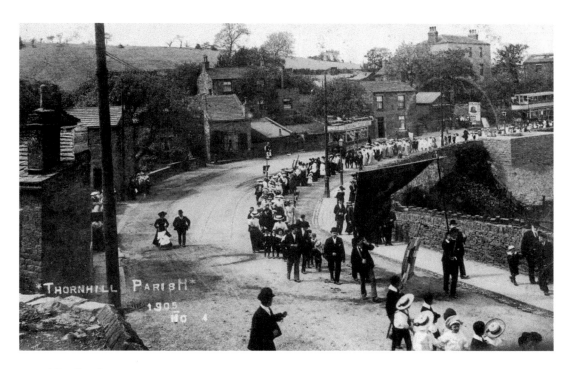

The Combs, 1905

A Thornhill parish church Whitsuntide procession, showing men, women and children winding their way towards the church. Two trams are parked at the terminus of their route. To the right is the site of Combs Pit, no longer functional. The pit suffered many disasters, but none worse than the underground explosion in July 1893, which killed 139 workers, who are commemorated by a memorial in the churchyard. Today, the trees have grown tall and cut out much of the view, while houses have been built along the ridge at the back of the hillside.

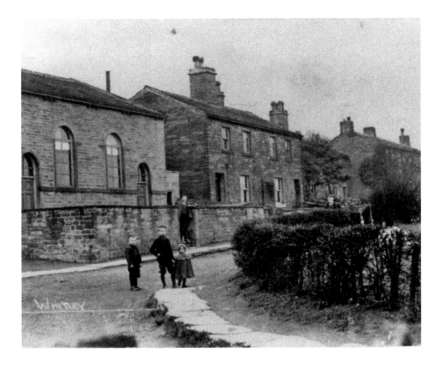

Scopsley Lane, Whitley, *c.* 1910

Children pose in front of Whitley Lower Wesleyan Methodist church. Whitley is a small village on the outskirts of Dewsbury which would have had a very small population, but they managed to support two churches. The chapel was closed around 1950; the building was sold off in the 1980s and converted to a single dwelling. It has changed beyond all recognition; one would not believe it was the same building! All the period features belonging to the chapel have been lost, including the arched doors and windows.

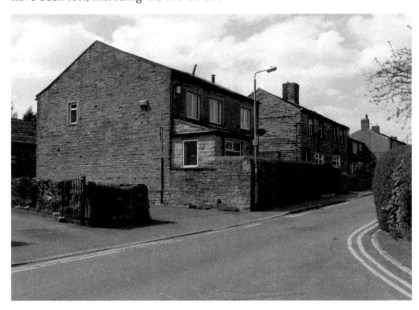

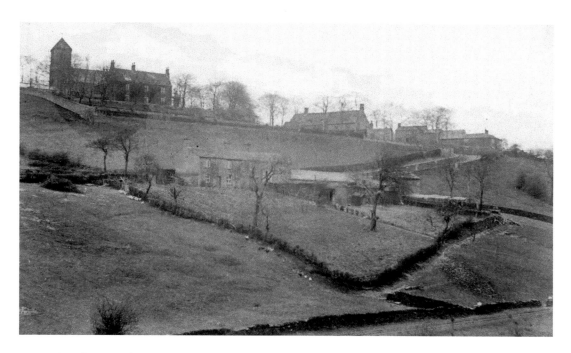

View from Back Lane, Briestfield, c. 1900

The view looking towards Whitley and its church, taken from Fawcett Field. This is probably the name of the farm in the foreground. Notice the distinct lack of any type of trees on the old picture and the mass of mature trees on the new picture almost obliterate the view. There are probably two reasons for this: perhaps because trees would have been cut down for domestic fuel, but more likely because the area was riddled with small private pits on the hillsides, and so the miners would require pit props to keep the shaft roof up.

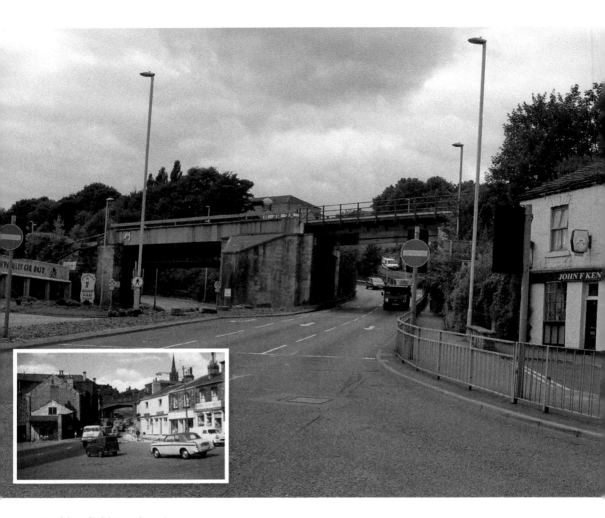

Huddersfield Road, 1961

Back into the town and Webster Hill, the two-way road snakes its way beneath the old cast-iron railway bridge, creating severe congestion at peak times. Vehicles struggled up the incline, then found it difficult to pass each other. The slope caused major problems with ice in winter; at one point, the council looked at the idea of underground electric heating to keep traffic flowing. By 1970, the bridge had been replaced with a much stronger steel and concrete bridge with an extra span, allowing the new dual carriageway to pass below.

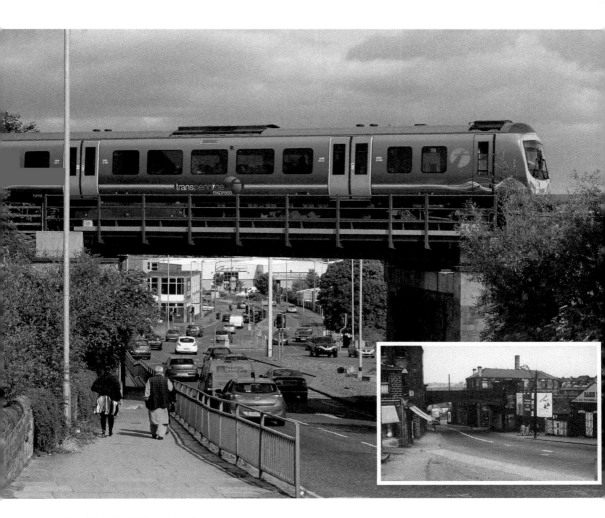

Huddersfield Road, 1961

The same old cast-iron bridge from the other side. Although this particular bridge has been rebuilt, there are several similar bridges still in situ nearby along this stretch of railway line. The replacement bridge now spans only one carriageway of the redesigned road layout, thus creating a much better flow of traffic. In advance of electrification of this railway line, a TransPennine diesel train passes on its way to Manchester Airport.

Huddersfield Road, Westtown, 1961

This view is taken at the junction with Watergate, which leads down the hill to several textile mills and engineering companies. The cluster of shops was a busy shopping centre for residents of Westtown and the Flatts, selling a variety of goods, from groceries to shoes. In the row were three public houses, one with a further two floors of workers' accommodation, surely a distant reminder of their obligation for the thirsty workers after a hard day's toil. This is now one part of the dual carriageway and, again, the trees have taken over.

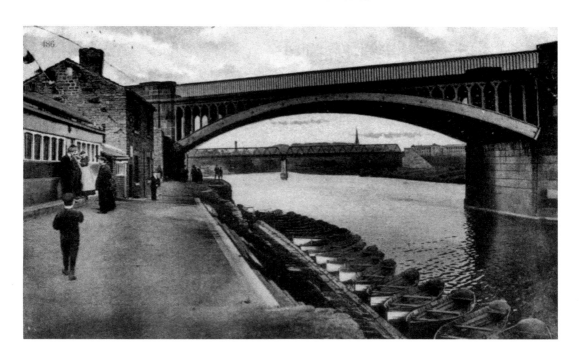

Ravenswharfe, *c.* 1900

Here was one of the leisure areas of Dewsbury, commonly known as 'Boat Sams'. It is a little haven of an undisturbed stretch of the River Calder, where boats could be hired out to row down the river. This was mainly a tranquil Sunday afternoon activity. In later years, a motor-powered vessel would take larger numbers for a trip down the river. Today, there is hardly a sign of any of the earlier activity, except some hardwood mooring posts just above the surface of the river. The whole area is severely overgrown, with trees that have taken advantage of the proximity of the water.

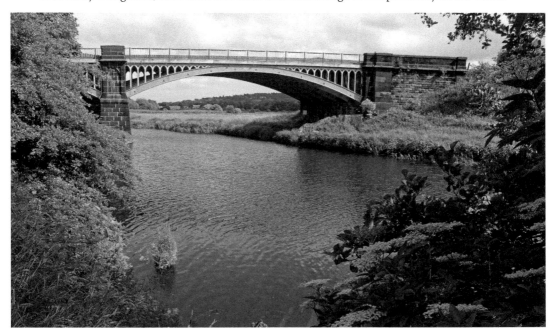

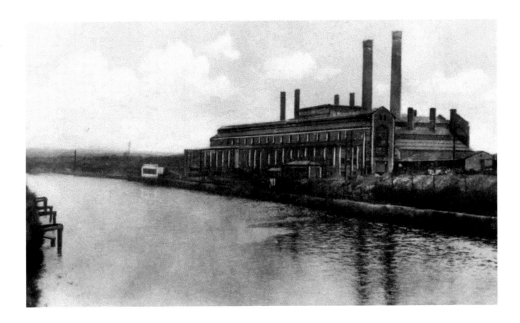

Calder Road, *c.* 1920

Viewed from the river bridge is Thornhill Power Station, the main producer of electricity for the Dewsbury area. It was upgraded several times with larger turbines, extra high chimneys to dispel the fumes and two cooling towers. The cooling towers became redundant in the 1970s, when one was demolished; the other disappeared in the 1980s. Gradually, the whole station was dismantled and parts were let as industrial units. Some new manufacturing processes have appeared. Again, the trees seem to have the last word.

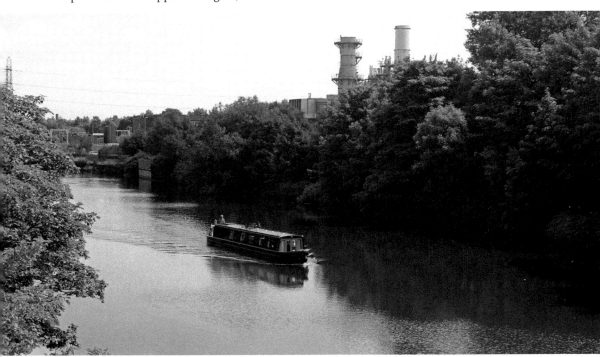

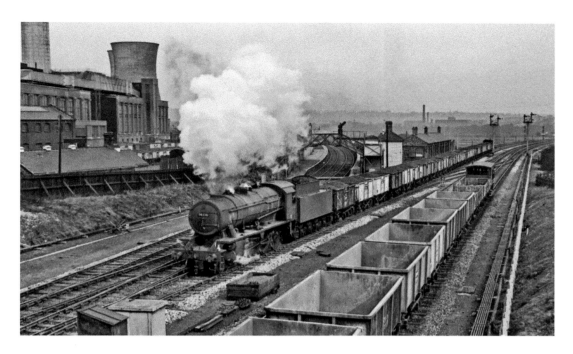

Calder Road, 1963

Ravensthorpe station lies on the Huddersfield to Leeds line, and was located next to Thornhill Power Station. This station was a rarity in that it was of timber construction. However, when the station became unmanned in the 1990s, vandals broke in and set fire to the buildings. The full extent of the power station can be seen as a steam-hauled coal train passes by. Today, the station buildings and power station have disappeared as LMS Coronation class loco No. 46233, *Duchess of Sutherland*, returns to Crewe with 'The Scarborough Flyer' in August 2013.

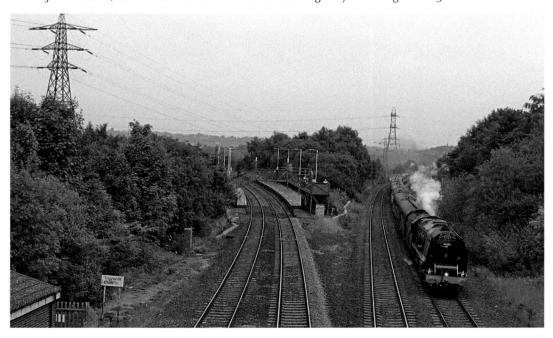

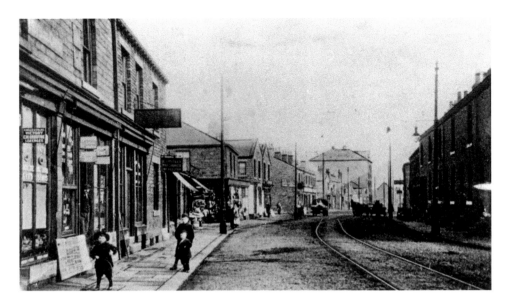

Huddersfield Road, *c.* 1905

In Ravensthorpe looking towards Dewsbury, the large building in the centre is the Ravensthorpe branch of the Dewsbury Co-operative Society, the largest outside Dewsbury town centre. The tram service ran regularly as far as Fir Cottage. However, in the early days, it was only single-decker cars that could access the area due to the low bridges *en route*. Today, Ravensthorpe seems to be a permanent traffic jam; it has far more traffic than it can cater for and a gyratory that fails to work!

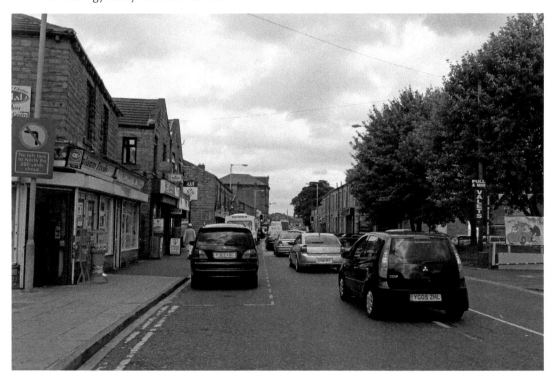

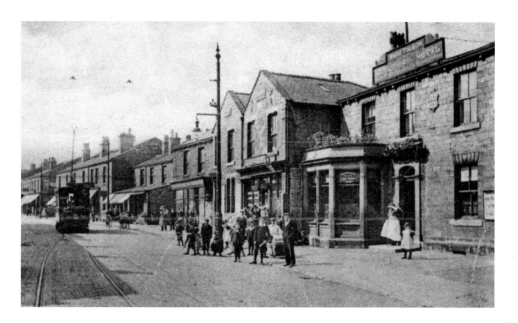

Huddersfield Road, *c.* 1910

Looking towards Fir Cottage, a multitude of shops ran from one end of the village to the other, selling everything that anyone could ever want. It even had its own Gas Showrooms adjoining the gas board site at the end of North Road. The shops are still there, but selling a diverse range of produce to cater for the various requirements of the community. It also had around a dozen pubs, including the Ravensthorpe Hotel, thus giving plenty of choice for the discerning drinker. Almost all have now disappeared due to different cultures within the population.

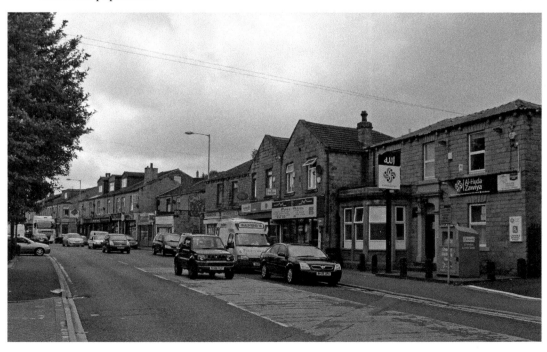

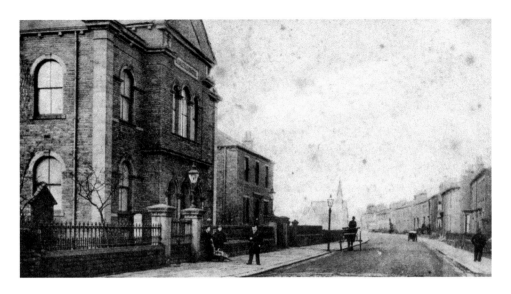

North Road, *c.* 1900

This road ran from the centre of the village, through the heavily populated housing area seen on the right, through Northorpe and into Mirfield. Religion played an important role within the local community. In the foreground is the imposing stone-built Wesleyan Methodist church, and in the far distance is the spire of the Congregational church. The detached house on the left, with the light outside, is the doctor's surgery. Congregations dwindled through the mid-twentieth century, and now the Wesleyan church has become a mosque and the Congregationalist church has been demolished for housing.

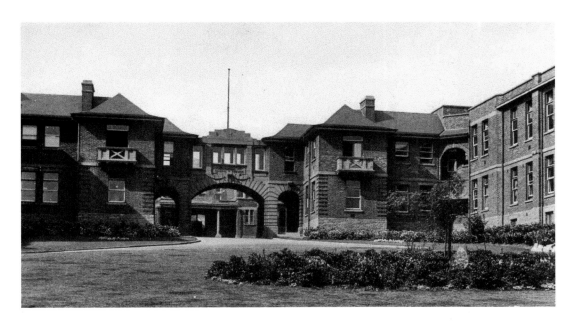

Moorlands Road, *c.* 1935

The new Dewsbury infirmary was built to replace the outdated one in Halifax Road. The final monies were raised by public donations and fundraising by local people. There was a grand bazaar from the 15–19 October 1929 to raise building funds – this alone raised £22,000. The new infirmary was completed soon after and opened in September 1930. When plans were afoot to demolish the infirmary and sell the site for housing, there was a public outcry, on the basis that money was raised by local people and the health authority thus had no right to sell the site. It was all in vain; the site was sold and is now a private housing estate.

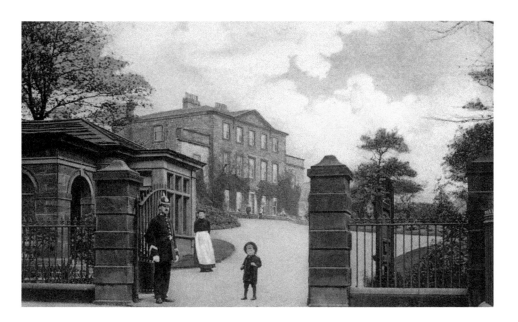

Cemetery Road, *c.* 1905

The main entrance to Crow Nest Park, built on 74 acres of land that was owned by the Hague family and sold to Dewsbury Corporation in 1889. It was opened in September 1893 at a cost of £10,000. Townspeople were given a one-day holiday, and it was officially opened as a great ceremonial occasion with 15,000 visitors. In August the same year, Dewsbury was privileged to host the Great Yorkshire Show in the new park. Today, the scene is almost the same, except that the head gardener's bungalow has gone; this meant that security was lacking and has led to vandalism in the park. In 2013, the Friends of Crow Nest Park secured a grant of £50,000 to bring the park back to its former glory.

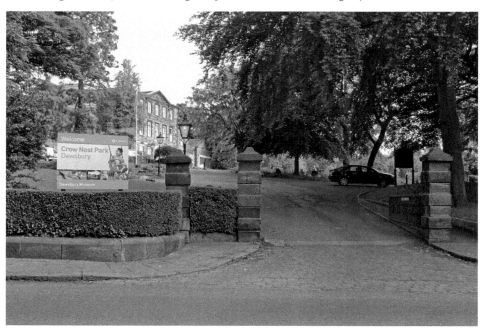

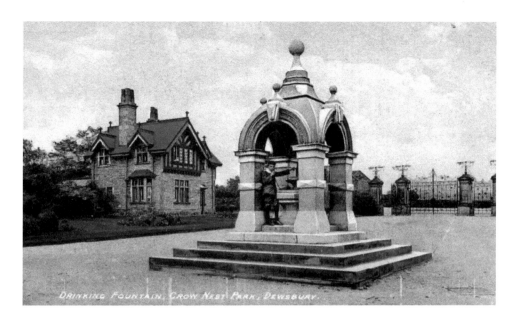

Crow Nest Park, 1910

The drinking fountain was built to commemorate the marriage of the Prince of Wales (later King Edward VII) and Princess Alexandra of Denmark on 10 March 1863. It stood in Dewsbury town centre for forty years. Due to vandalism (even in those days), it was removed, refurbished and re-erected near the Boothroyd Lane entrance to the park. After the First World War, a new war memorial was planned for the park, and the most appropriate place for it seemed to be where the fountain stood. So, in 1924, it was re-sited lower down the park, and the impressive new cenotaph was erected in its place.

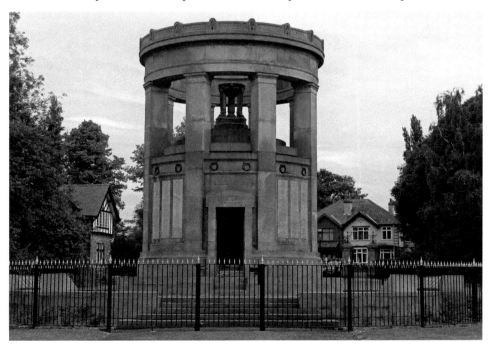

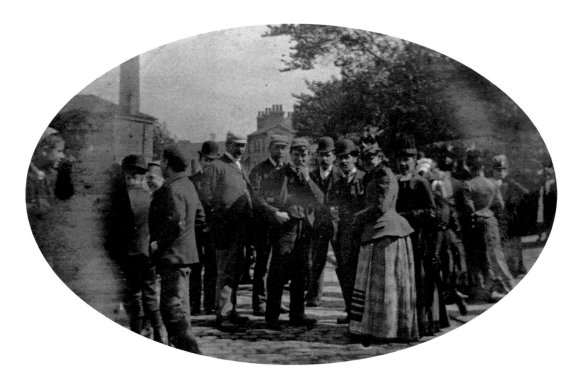

Halifax Road, *c.* 1891

On Whit Monday churchgoers gather in Halifax Road, by the junction with Springfield Terrace, prior to the joining of their Whitsuntide procession to the Congregational church. The group were associates and friends of the Revd Henry E. Arkell, pictured in the centre, wearing the bowler hat. He was the pastor of the church from 1891 to 1895. On his retirement, pastoral helpers of the church presented him with a small bound album, with pictures reminding him of his time there, and this is one of those pictures. Today, you would not want to stand in the middle of the traffic on Halifax Road.

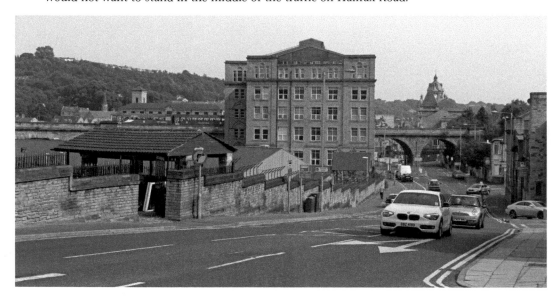

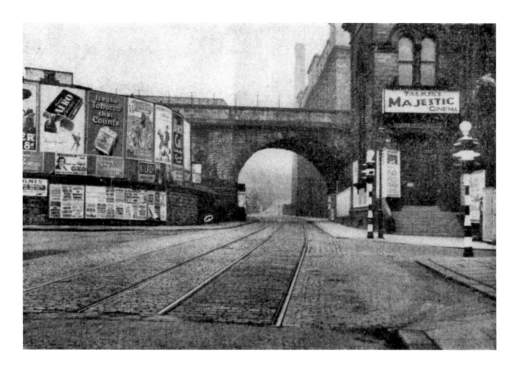

Halifax Road, *c.* 1936

This busy road entered Dewsbury through just one span of the railway viaduct. The huge textile mill of Mark Oldroyd can be seen through the arch. To the right is the Majestic Cinema, later renamed the Rex. This was formerly the Congregational church, referred to on the previous page. Note the traffic lights, which for many years were the only ones within the Dewsbury boundary, whereas now there are over 100. After the war, the road was widened and a new arch added to the viaduct. With the building of the ring road, the whole view of the viaduct was revealed.

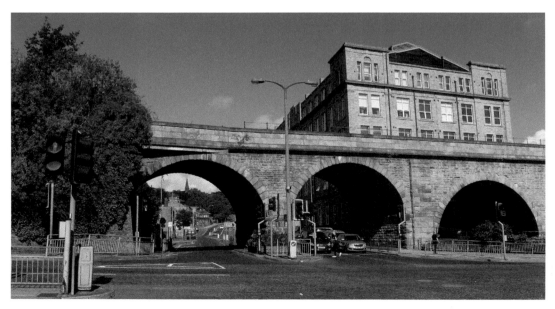

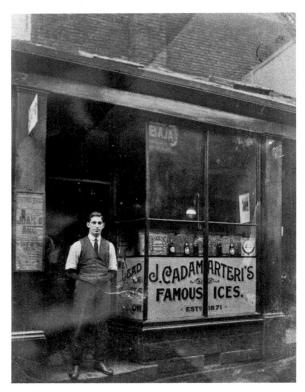

Caddy's, *c.* 1905

John Cadamarteri was eighteen when he started out in business. With 2*s* (10p) given to him by his father, he bought butter, sugar and milk – the ingredients to make ice cream. He sold this from carts sited around the town centre. He bought premises in Robinson Street in 1925 and converted it into an ice cream parlour with its own factory. He was often fined 10*s* by the magistrates for opening on a Sunday, but chose to carry on. John lived on Leeds Road, and died in 1977 aged ninety. Today, we still have an ice cream parlour, Igloo, but this is situated in Northgate.

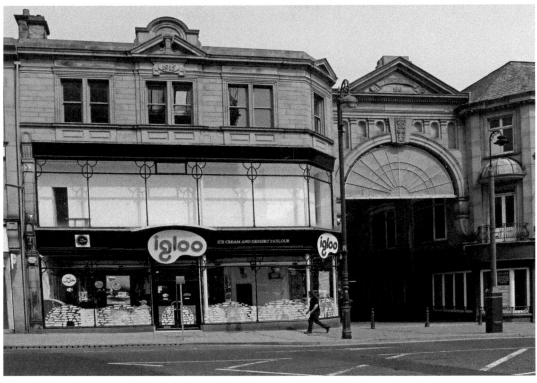